IMAGES
of America

AROUND FORTESCUE

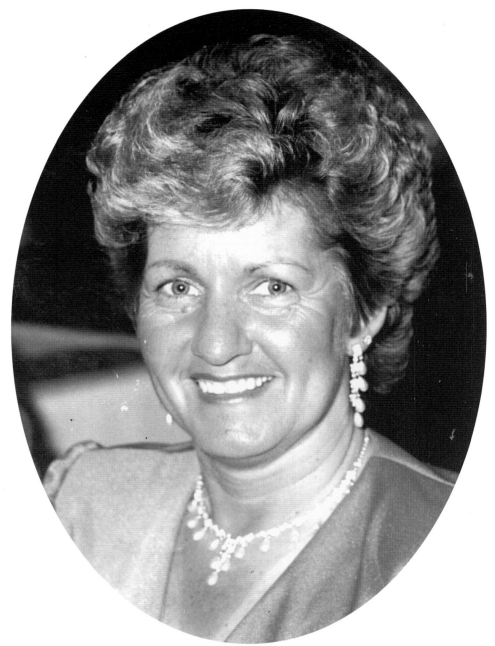

Betty Higbee, pictured above, and Clarence "Bunky" Higbee have wanted to share the significant heritage and stories that make up the rich history of Fortescue and record it for all to enjoy for many generations to come. So grab a hot drink and settle in to enjoy the history as told to Betty by Bunky and others.

On the cover: Please see page 28. (Courtesy of Marion Moore.)

IMAGES
of America

AROUND FORTESCUE

Betty Higbee and Clarence Higbee Jr.

ARCADIA
PUBLISHING

Published by Arcadia Publishing
Charleston SC, Chicago IL, Portsmouth NH, San Francisco CA

Printed in the United States of America

Library of Congress Control Number: 2008937788

For all general information contact Arcadia Publishing at:
Telephone 843-853-2070
Fax 843-853-0044
E-mail sales@arcadiapublishing.com
For customer service and orders:
Toll-Free 1-888-313-2665

Visit us on the Internet at www.arcadiapublishing.com

*This book is dedicated to my husband of 50 years,
Clarence Higbee Jr.; my children Clarence III, Cynthia, Clifford, and
Charles; and grandchildren Robin, Clifford, Michelle, Gabrielle, Tia,
and Tori, all of whom were born and raised in Fortescue.*

—Betty Higbee

CONTENTS

ACKNOWLEDGMENTS

We would like to extend our deep appreciation to those who took the time and effort and graciously shared their prize collection of memorabilia by opening their treasured family albums, or just traded a postcard or two. Maybe you sat down with us and joyously recalled an old memory of times past. You all have our sincerest gratitude and deepest thanks: Sam Blizzard, Mary Ann Casper, William Cooper, Joe and Joan Evans, Frank and Ila Green, Sarah Hartman, Bill and Evelyn Lacy, Ronald and Judy Loper, George and Marion Moore, Earl Shull, Alvin Shute, and George and Judy Stanger. We want to thank everyone who took time and effort to produce a picture even though it might not have been used due to publisher's discretion.

Pamela Brunner, thanks for your expert advice and enthusiasm. You never stopped digging.

Thank you Tamara (Tammy) McGinley for the invaluable use of your laptop computer.

We would especially like to thank Daphne Terhune for all her hours of typing and organization. Most of all for the everyday encouragement you gave and the spiritual strength needed to make this book possible.

Unless otherwise noted, images appear courtesy of the authors.

INTRODUCTION

Fortescue, a small island in southern New Jersey in the township of Down, Cumberland County, is situated on the eastern shores of the Delaware Bay. The island was named after Lord John Fortescue of Cullington, Great Britain, when his wife Mary (Salter) Fortescue was bestowed a deed to the hamlet and they decided to come and settle and develop the 10,000 acres in the early 1700s. It seems Lord John Fortescue could not possibly have envisioned the enormous popularity the island would come to enjoy. For some unknown reason, John and Mary sold the precious land to William Smith in 1776 for only five shillings. Lord John Fortescue, however, must have owned the island long enough to have his name appear on maps drawn before the Revolutionary War and his name put on the town.

Getting into Fortescue in the very early years was no easy matter. Nearly two miles of decaying vegetation lying on top of the marsh had to be navigated and crossed over to reach the island. To make it possible to cross, brush and mud were laid down in a straight line along with pieces of logs, creating the famous "Corduroy Road." The "clickity clackity" sounds of the horse and buggy as it traveled across the Corduroy Road could clearly be heard by all. What a strange feeling it must have been to see the road disappear into the marsh on the next extra-high tide.

Military companies would pass through Bridgeton on their way to Fortescue to spend a week of camp life. The Independent Rangers, with their bayonets, gave Fortescue a happy and animated appearance. During this time, bay parties, as they were called, were held to the pleasure of the landlords as they were ready to "do up" the fish and oysters in style for everyone who came to observe all the military tents pitched on the large sandy beaches.

The Garrison family is considered the first family of Fortescue—Herbert and Laura Garrison with siblings Elizabeth, Lewis, Lehman, Ralph, and William. In the late 1800s, Herbert, son of Lehman Garrison, either by purchase, foreclosure, or gift, owned the entire landscape of Fortescue Island. This fueled the beginning of the great Garrison dynasty. When the Garrison Hotel, owned by Herbert, burned to the ground in the late 1800s, Fortescue went into a slow decline. This hotel was the main attraction and drew many a hungry visitor to the island. But in 1901, Herbert began selling building lots, which caused the island to become alive again. Imagine how exciting it must have been when in 1904 the first bridge was built over Fortescue Creek. The bridge had to be one of Fortescue's greatest achievements ever.

A taxi service was established from the mainland. George Duffield and Chester Bradford were some who would meet the trolleys in Newport to transport passengers to and from Fortescue with their horse and wagons.

There were leather-skinned captains who would build their own fishing boats while living in a houseboat along the shoreline. Fortescue was said to be one of the finest fishing and hunting

grounds on Delaware Bay, which dwarfs all other bays in New Jersey. Fortescue always offered a large fleet of fishing boats and captains that were said to be the finest group of party boat fishing afloat.

Prohibition had a strong influence on the popularity of Fortescue, which was a good unloading point for brazen rumrunners. Many of the popular captains used their party boats as a "by boat" going out to meet the larger boats and bringing back the illegal alcohol to the waiting trucks on shore. This helped the captains subsidize their livelihood, after a slim summer and a long cold winter. If a rumrunner had a profitable run at night, he would slip into the wonderful and very popular dance hall over the water that belonged to Floyd Dill and pay the live bands a large sum of money to keep the festivities jumping until the wee hours. After all, he needed to keep the local people happy and on his side.

The wonderful, nearly one-mile deck boardwalk lured hundreds of visitors into town for a leisurely stroll on a hot summer's day or to watch the great sunsets in the evenings. It was a delightful way to enjoy the delicious smells, sights, and sounds coming from all the hotel lobbies. Soon visitors to Fortescue would become very adventurous and would want to visit the notorious but very popular speakeasies that became prevalent in town for some scandalous excitement. The darkened establishments with the peepholes in the doors, sporting catchy names such as the Gray Goose and the Green Door, gave them plenty of excitement if they by chance were there during a periodical raid by the Alcohol Beverage Control.

There were a dozen prominent family-owned rowboat marinas that flourished in town, renting boats with or without motors. A small mom-and-pop variety store was always attached for bait and snacks. On a busy summer day, 100 or more rental boats could be seen going out in the bay.

The famous Philadelphia Sketch Club would come to Fortescue each summer and spend a week at the Preston and Hubert Foster cottages putting all these "only in Fortescue" activities on canvas. The popular, well-known artists' club boasted it would never run out of ideas to paint on Fortescue Island. Before returning to the big city, the artist's canvas was sold or given to a cottager.

There were many devastating floods and disastrous fires that nearly tore the heart and soul from the small two-mile-by-two-mile island, but Fortescue was and still is the oasis of Cumberland County due to its rich natural resources and family entertainment. In the early 1930s, roads and automobiles greatly improved and tourism began to fade drastically as vacationers could easily travel to farther shores with larger beaches. But Fortescue has always come alive in the spring. Today the fishing may have changed, but the devoted fishermen remain the same. When the season ends, all the broken tackle and the large fish tales are put away until next season.

Now there are no more boat rental marinas, the boardwalk and dance halls are gone, and inns and lodges have disappeared. Only the Hotel Charlesworth, today under the direction of Jim and Shirley Fonash, remains. Its splendor offers a glimpse of the fascinating past history of Fortescue.

So, grab a chair, relax, and enjoy the vintage pictures and some great history as told by the people who lived it, loved it, and remembered it.

One

SAILING AROUND

Sailing around the town for many who lived in the Bay Shore area was a passionate way of life. The strong smell of the decaying marshland that comprised the small fishing and hunting area's life seemed so very tranquil with the Delaware Bay delivering to residents and their boats' men a bounty of rich natural resources to be harvested and respected. There is a richness to be found here in the great variety of fish and shellfish in the bay, the migratory birds that come and feed on the horseshoe crab eggs, and the duck and muskrat populations. The cycle of life ebbs and flows with seasons.

Fortescue, with its noble beginnings, will always remain a very peaceful hamlet with only one way in and one way out, helping to make the community a very close-knit family. Many of the once summer residents have chosen to leave the big cities and make Fortescue—with a population of less than 500—their permanent home.

The bay swells and recedes and the people come and go, but one only needs to spend a very short time here to acquire a longing for the past history of Fortescue: for old-timers traveling here on the old Corduroy Road with the town bursting at its seams with vacationers.

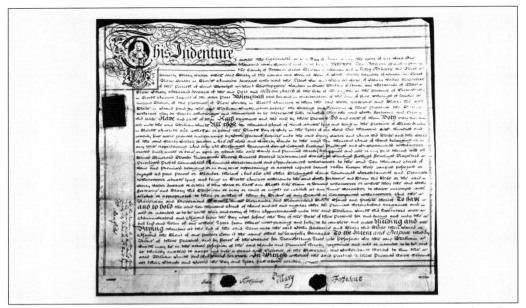

This is the deed used between Lord John Fortescue and wife Mary (Salter) Fortescue when they sold some 10,000 acres of land to a William Smith for five shillings on August 14, 1776. The writing on the side of the deed reads, "Let this indenture be enrolled of records in his majesty's court of Kings Bench for safe custody only dated the 14th day of August 1776." It is signed by Moorsfield.

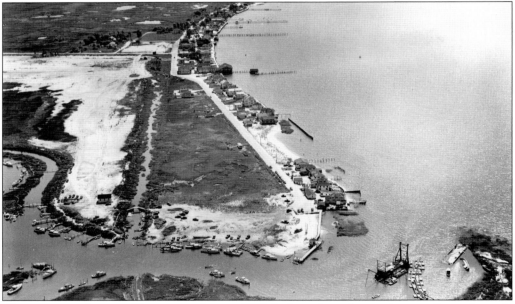

This is an aerial view of Fortescue taken in 1930. It shows how the creek was split, and people had to cross over small footbridges to get to the boats. Another footbridge was over the canal high enough to accommodate large boats. Some of the oystermen would use the canal for winter refuge. One boat never left, it rotted away and is still on the bottom behind the chapel. The beachfront was already full to capacity by this time.

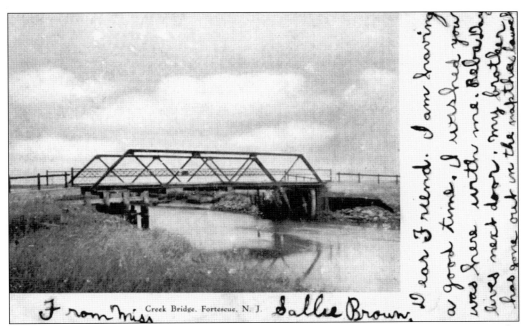

Creek Bridge. Fortescue, N. J.

From Miss Sallie Brown.

Dear Friend. I am having a good time. I wished you was here with me. Belinda lives next door. my brother has gone out in the night the [...]

In 1904, this one-lane, steel-trussed bridge with wood planking was the first bridge crossing the creek into Fortescue. It was built by the Berlin Construction Company of Berlin, New Jersey. The Cumberland County Freeholders at the time were chairman Peter Cambell, S. B. Fagen, B. F. Hires, H. O. Newcombe, and E. E. Rogers.

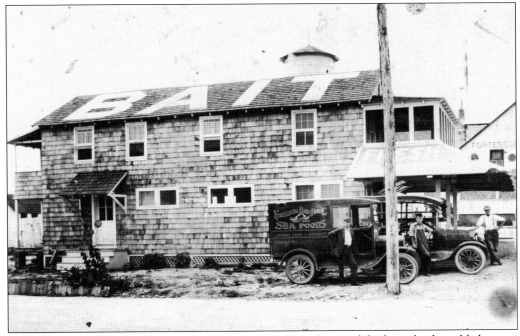

In 1908, Thomas Pugh's bait house was one of the finest bait and fresh seafood establishments in Fortescue, advertising shedder crabs and oysters as their specialties for all to enjoy. This wonderful building was located on New Jersey Avenue near the water tower.

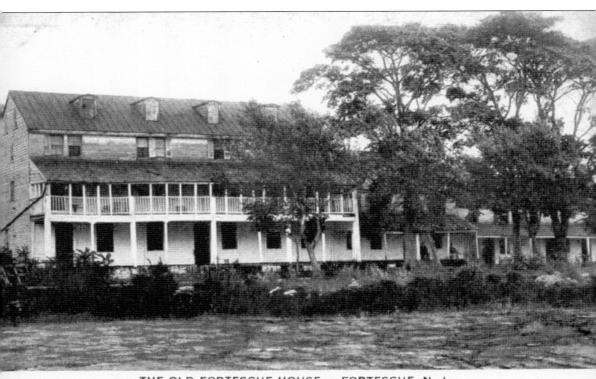

THE OLD FORTESCUE HOUSE — FORTESCUE, N. J.

The Old Fortescue House was one of the oldest hotels in Fortescue. The hotel was central to Fortescue's economy, as it boasted the only restaurant in town. Over the years it had enjoyed four renovations, bringing the room count to 48. It was originally built around 1825 and burned to the ground in 1892. Herbert Garrison was spending the weekend with his family getting the hotel and restaurant ready for the summer season. Within a few minutes of smelling smoke, the old watering hole was no more. Albert Lore saw the great glow in the sky from Newport and just knew there was a devastating fire in Fortescue. He and others came by horse and buggy, and some heroically walked the distance to battle the flames. Some of the old heroes were Albert Lore, Harry Cosier, Morton Robins, and Harry Johnson. These men and many others witnessed the demise of the Old Fortescue House that night. This was a great step backward for the small community and a very sad time.

What a fabulous sight in the morning on the bay in Fortescue—fishermen lined up on a pier awaiting their turn to board a fishing vessel, the beautiful white billowing sailboats out in the distance already at work, the party boats *Franklin* and *Alice* loading up for their fishing day, and rowboats awaiting their turn.

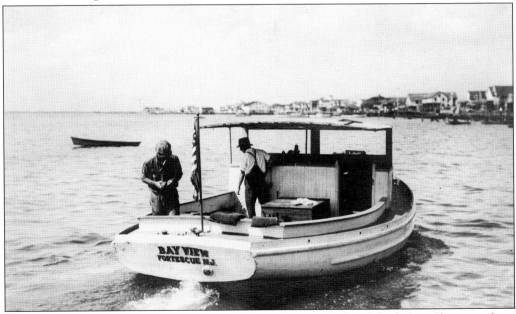

Seen here in the 1920s, Fortescue captain William Frazier is behind the helm of his party boat *Bay View*, headed to shore after a day fishing with mate Stogie Joe. This was a Jesse Moore–built boat from Cedarville. To charter a trip on the *Bay View*, the number to call was 3-R-4.

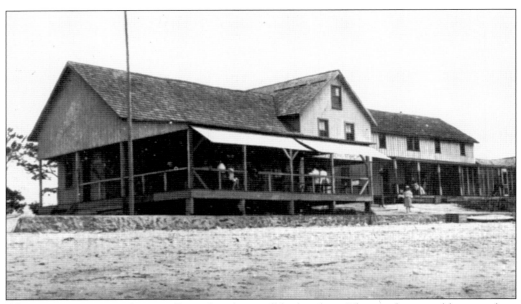

Above is a rare tranquil scene. Soon the place will be bustling. The pavilion would succumb to fire. The next pavilion, below, was again a very popular place for old and young alike. Lightbulbs strung along the pier would light the way for a long stroll after David Strain showed a full-length movie on a warm Saturday evening. The movies were always current, but the young people always wanted Laurel and Hardy.

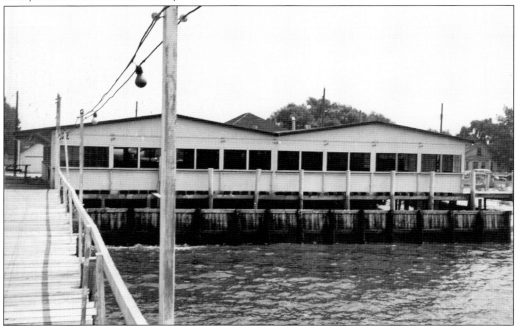

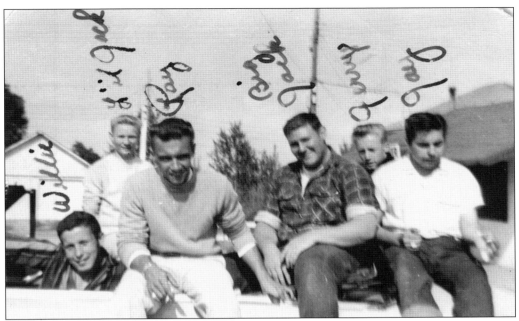

The picture above shows some fellows in 1959, anxiously waiting for the girls to show up. They are William "Willie" Goldate, Jack Messick, Ray Hill, Jack Groff, Jerry Bryan, and Jay Smith. The picture below was also taken in 1959. The folks who have been enjoying the weekend are Richard Henderson, Janet Gebhardt, sister and brother Jean and Willie Goldate, Phyllis Dengas, and Robert McDowell. They are finding it hard to say good-bye until the next weekend.

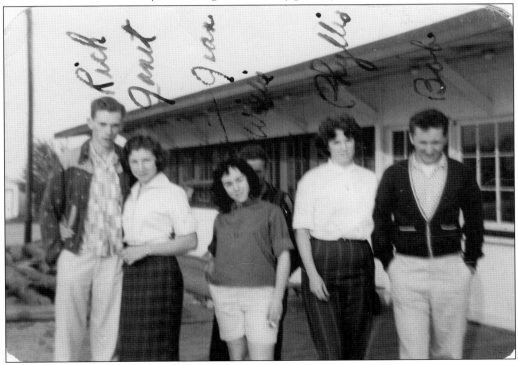

Sophie Loper, Gladys Sharp, Sally Sharp, Oliver and Ida Green, John McGray, and Joe Evans (sitting) enjoy dessert after a grueling civil defense meeting in the Fortescue fire hall.

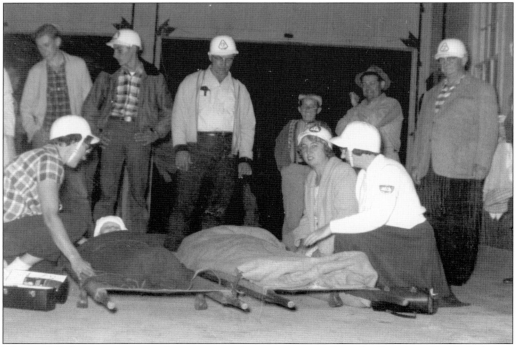

The civil defense group spent hours two to three times a week in the Dividing Creek firehouse learning to tie bandages and administer first aid.

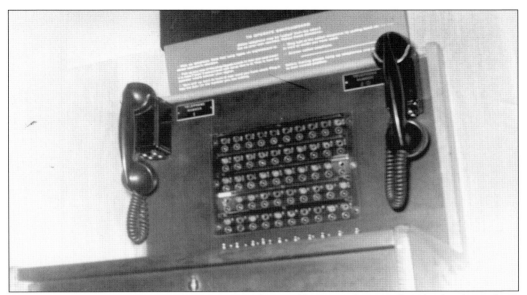

This wireless, two-receiver communication radio could get word out to hundreds of people in a short time. Around 1941, government-organized citizens decided to get groups of concerned citizens to have civil defense meetings. The government passed out pamphlets with photographs of suspicious airplanes to keep an eye on. It was not uncommon for someone to be eating supper and hear a plane overhead, run from the table, and grab a pair of binoculars to try to identify the aircraft.

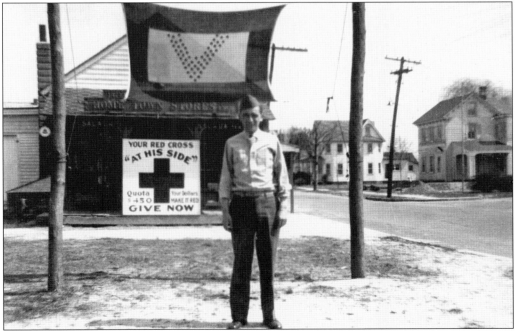

Pictured here in 1941, Charles "Shug" Woodlin of Newport stands in front of Peter Gaskill's hardware store on the corner of Baptist and Fortescue Roads, asking people to give blood to the Red Cross to help the war effort.

In 1952, Gladys Mae Sharp became the eighth postmaster in Fortescue. The post office was located on the corner of Pennsylvania and Bayview Avenues, on the front porch of Sharp's home. Getting the mail was a great treat, as the smell of something good cooking was always coming from her kitchen. Sharp retired in 1967, and Judy (Fowler) Loper became the next postmaster. The post office was relocated in the former location of the Charles Nickoles general store on the corner of Downe and Garrison Avenues. Loper would hold this postmaster position for the next 38 years. In 2006, Joan Evans became and still is the Fortescue postmaster. All the people who have been postmasters in Fortescue are Zaccheus A. Joslin, Edmundt L. Kelly, Thomas H. Pugh, Earl Lumby, William H. Frient, Mary B. Hickman, Chester D. Bradford, Gladys M. Sharp, Judith F. Loper, and Joan T. Evans.

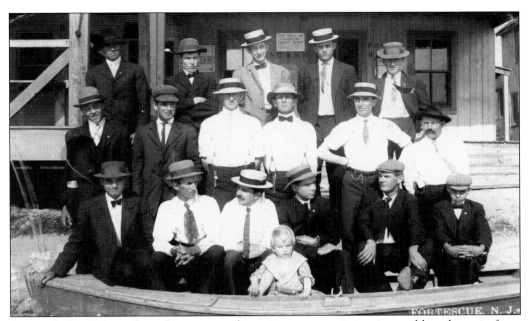

A crowd of well-dressed gentlemen poses for a picture, some sitting in an old rowboat, in front of the Lumby General Store and post office. The sign on the building reads, "We sell Cedarville Bakers Bread." This was a small bakery in Cedarville that delivered fresh bread and baked goods to Fortescue by horse and buggy.

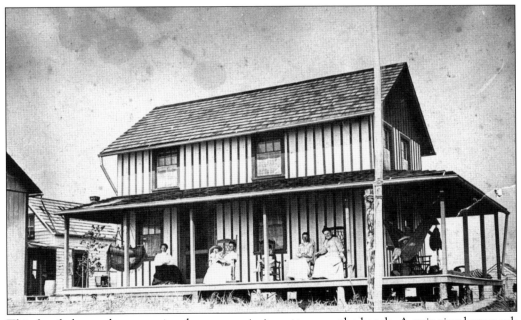

This family knows how to enjoy the summer in its cottage on the beach. A swinging hammock on either end of the porch has a person sleeping, the right end of the porch has people lying on blankets resting, and the rest are rocking away in their rocking chairs.

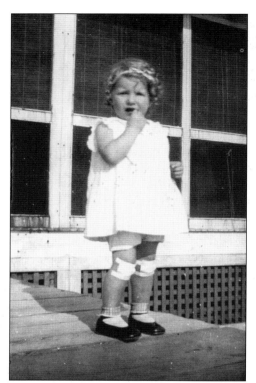

In the summer of 1931, Betty Marie (De Bere) Estadt of Cedarville, then one and a half years old, came to Fortescue with her family to stay at the Bauer House and walk the boardwalk every summer. The boardwalk was not too friendly to her as she tripped and skinned up both knees, as is seen in this photograph. Mom took her for an ice-cream cone a few doors down. That helped the knees to soon feel better.

This dance hall, belonging to Floyd Dill, was built out over the bay and was a happening place on the weekends in the 1930s. People came from miles around to dance and listen to live bands. If a rumrunner came ashore after a profitable evening, booze and money flowed like water and the band was given a large sum to play clear into the night. The popular dance hall was always filled to capacity. With the windows open in the summer, people on the whole island could hear the laughter and the bands by just sitting on the boardwalk or the beach.

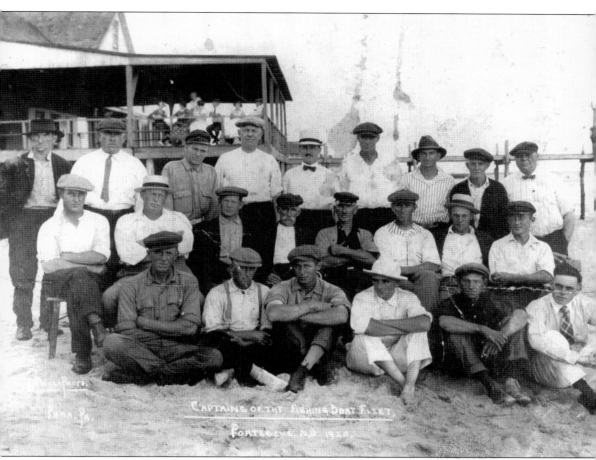

A large group of weather-beaten, hardworking boat captains poses for a rare picture in 1920 in front of the Hundermarks Pavilion. They represent the fishing fleet of the day. Some wore ties, some no shoes, but they always wore hats. The first captains association was formed in 1914. Capt. Samual Moore was president, and Capt. Conrad Ghring was secretary and treasurer. There was only one telephone on the island at this time, and the captains had to stay friendly with the store owner or they would not receive their charter messages.

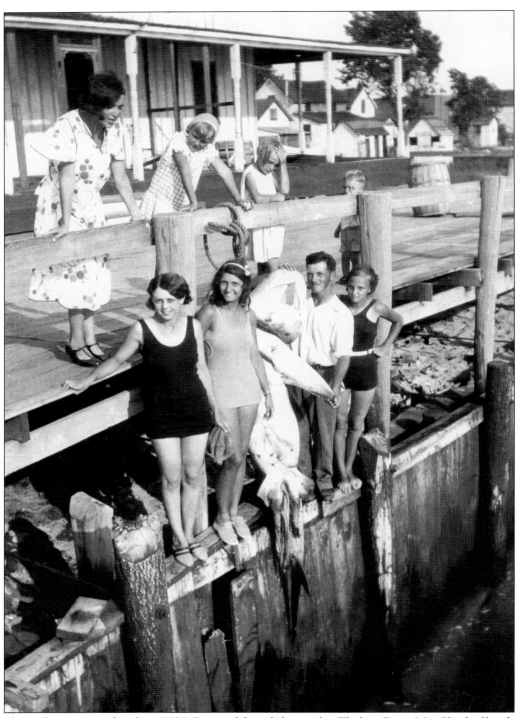

Shown here are catches from 1930. Pictured from left to right, Thelma Dare, Mrs. Kirchoff with a large shark caught by Earl Dare, Rulon Brooks, and Margaret Bowen are showing off the large fish in front of the Hundermarks Hotel.

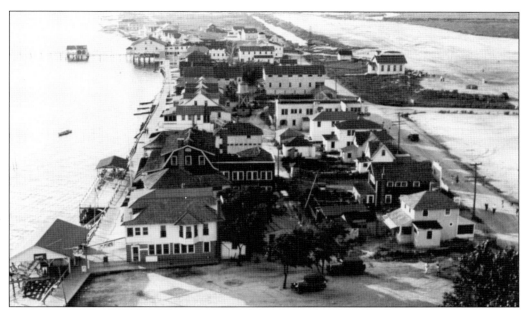

Looking north in this 1930 photograph, the first beautiful building is the Mayflower Restaurant and Pavilion and then the Hotel Charlesworth and Pavilion owned by Ruella Charlesworth. The water tower built in 1933 can be seen in back of the Hundermarks Pier. Continuing north up the boardwalk, one can see the Garrisons Hotel and Pier and bait house, as well as the popular dance hall of Floyd Dill out over the water. To the far right sits the Fortescue Chapel.

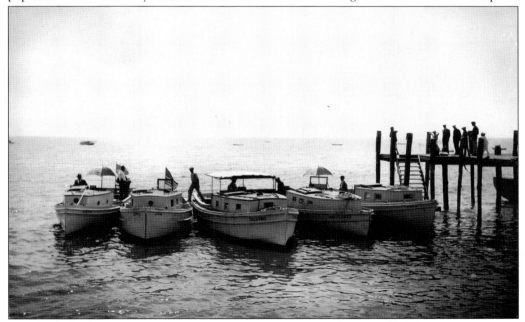

In this 1920 photograph, a captain makes the hazardous walk between boats. Sometimes the public had to do this, and it was a little scary. Note that some of the captains are wearing a suit and tie. Fishing boats *Evelyn*, *Columbia*, *Mayflower*, and *Clara B* are tied together, waiting for their customers to arrive.

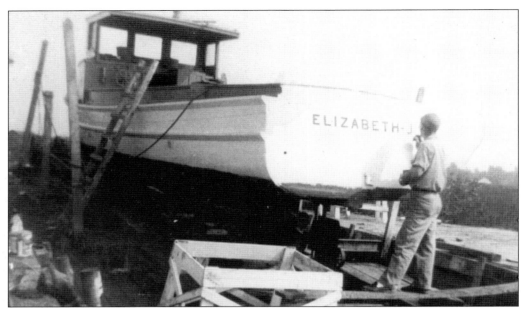

In the early spring, captains are busy preparing their fishing boats for the upcoming summer season. They take turns using the only railway in town. After the boat is scrapped and given a fresh coat of paint, the name of the vessel is hand-painted on. Here Edward (Ned) Gandy paints *Elizabeth J* on Capt. Jim Higbee's party boat while it is on the old wooden railway of Clifford Finley.

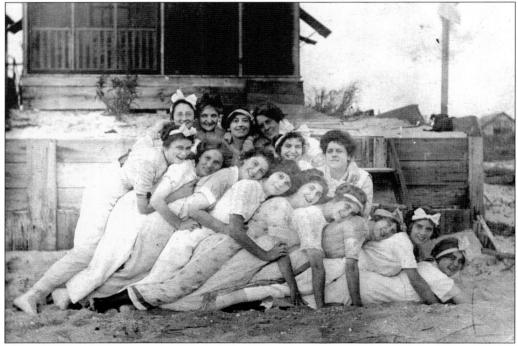

These lovely ladies seem to be enjoying themselves on a lazy summer day in 1908. They are having fun in the warm sand in front of their cottage.

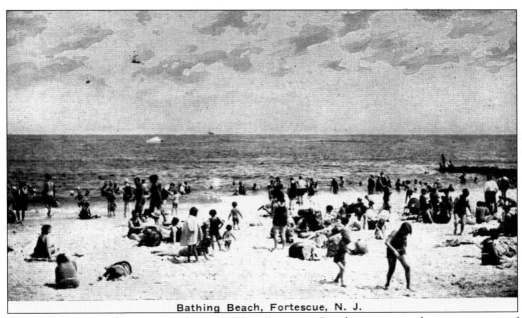

Bathing Beach, Fortescue, N. J.

Crowds gather on a hot summer day in 1925 on Fortescue Beach to swim in the warm waters of the Delaware Bay. Others lay on the sand to soak up the rays of sun.

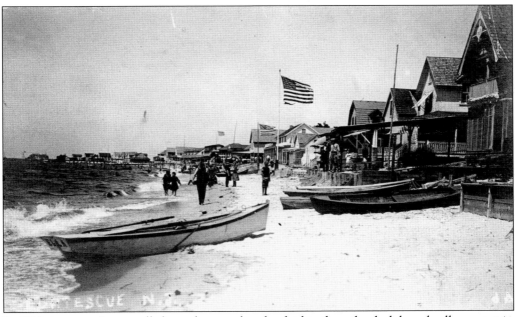

In 1910, it was easier to walk from place to place by the beach as the deck boardwalk was not in existence yet. In that period, folks just dragged up their boats to the front of their cottage.

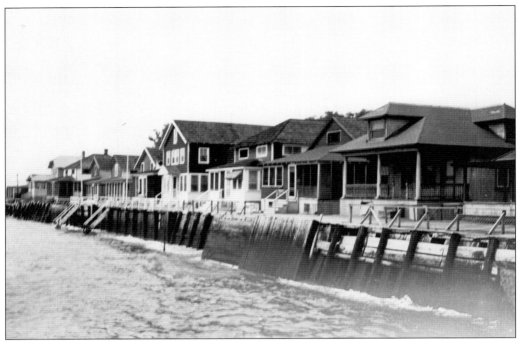

Here in 1930 is a good look at the completed deck boardwalk. This beachfront is south of the Garrison Hotel featuring some of the finest summer cottages sitting proudly on the boardwalk.

In 1910, horse and buggies carry Sunday school children to picnic in Fortescue for a day's outing. Emma Allen remembers how much she enjoyed coming here and swimming in the bay and playing games after the picnic on the boardwalk. The winner received a hokey pokey for the prize. A hokey pokey was a slab of ice cream between a sheet of paper.

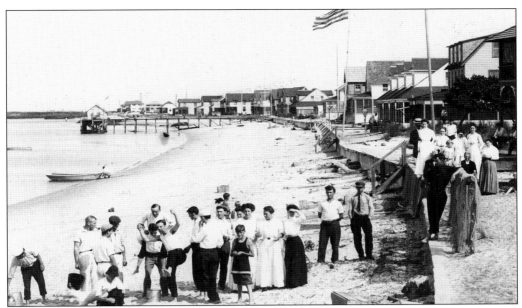

In 1905, Fortescue Beach began to swell with summer cottages. Looking north is a glimpse of the bulkhead that was constructed to hold the sand in place. During the winter months, the strong wind and tides washed out the sand behind the bulkhead, leaving a large hole in front of the cottages. This is what birthed the deck boardwalk. The boardwalk was constructed from their homes to the bulkhead.

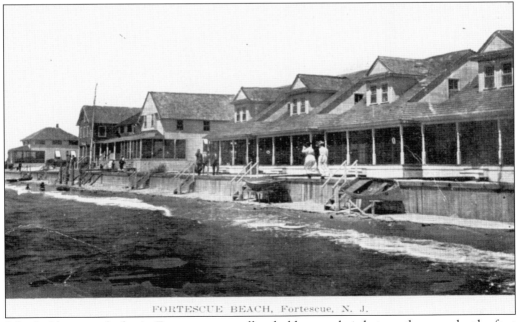

FORTESCUE BEACH, Fortescue, N. J.

It looks like a windy day in Fortescue, as strollers hold on to their hats as they pass by the four identical cottages that were built and owned by the Parker brothers in 1915. The brothers owned Parker Brothers Glass Factory in Bridgeton.

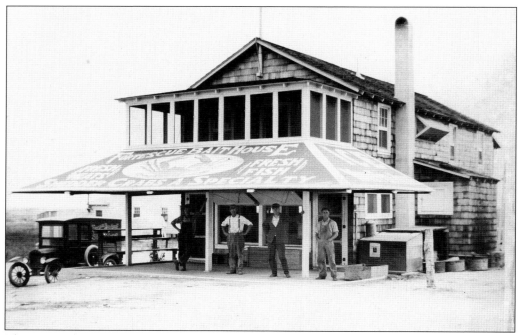

Thomas Pugh, second from the left, stands with unidentified friends in front of the Fortescue bait house he owned and built. His wonderful old truck was used to deliver bait. Pugh was instrumental in the construction of many of the businesses in town.

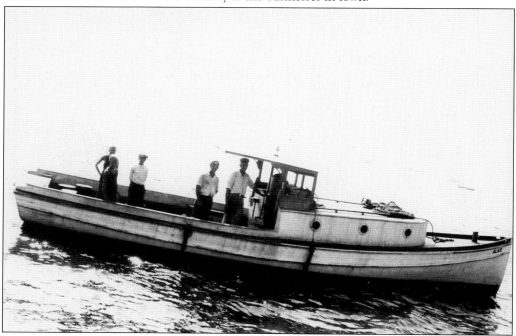

Pictured here is the fishing boat *Alice*, owned by Capt. Jesse Dare. At the helm is Norris Cossaboon. Standing behind him are Rulon Brooks and two unidentified friends. The rate for chartering the boat for six or less people was $12, out of which the mate received $1 a day.

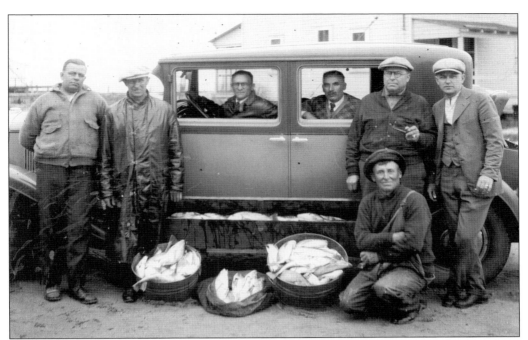

It looks like the mob had a great day of fishing as the running boards are full of croakers. The driver looks to be ready for a quick getaway. Croakers at this time were being caught by the hundreds.

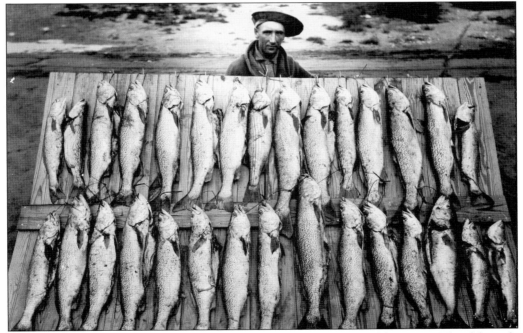

Oscar Bradford proudly displays his exceptionally large catch of weakfish in 1920. This fish made Fortescue claim the title of "Weakfish Capital of the World." Fresh fish such as these were sold to the restaurants on a daily basis. This is a prime reason the eateries were so popular.

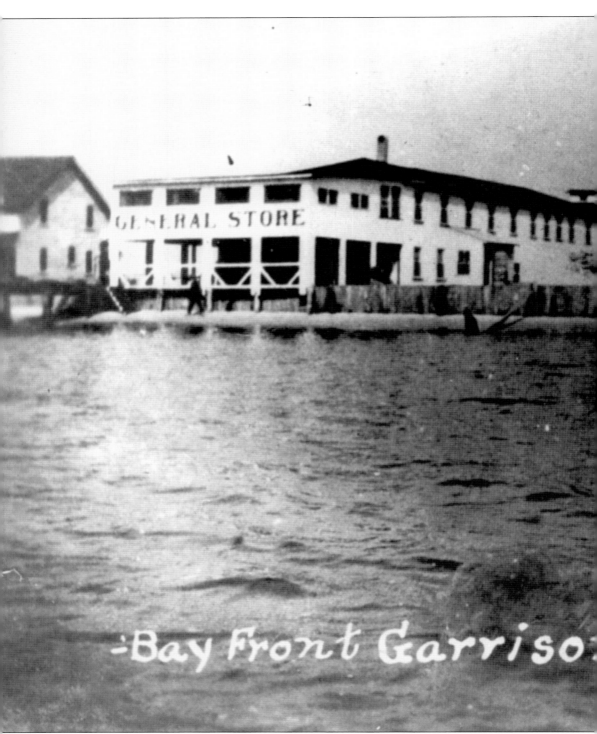

GENERAL STORE

Bay Front Garriso

This wonderful view from the bay captures how grand some of the buildings were along the small beach. This picture reflects the era of the Garrison dynasty with the grand hotel and huge

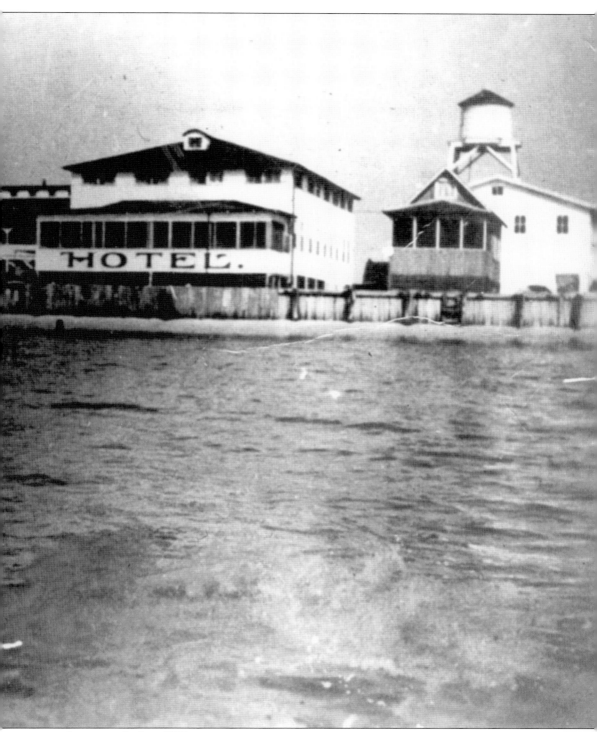

general store in the late 1920s.

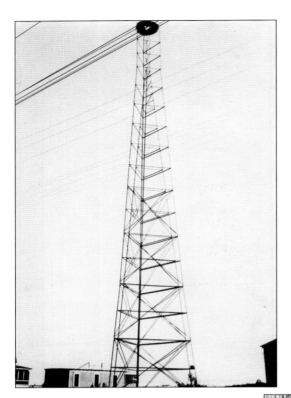

In 1930, this geodetic survey tower was placed behind the Hundermarks Pier. Most of the aerial photographs from this time period were taken when Rulon Brooks climbed to the top of the tower.

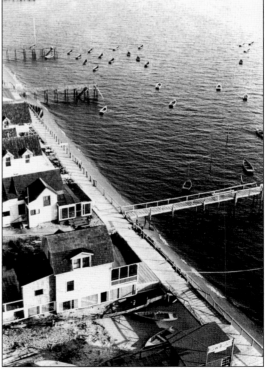

Looking south on Garrison Avenue are Walter Rhubart's rental boats, tied to steaks in the bay. His son Bill would swim out to retrieve a boat for a customer. Sometimes a summer storm could break them loose and scatter them or break them up on the bulkhead. There are also boats on pull ropes.

This is the center of town looking south along New Jersey Avenue. This wonderful landscape with the famous boardwalk and long piers would soon change after the 1950 flood and the 1963 fire.

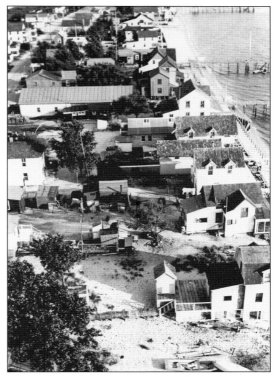

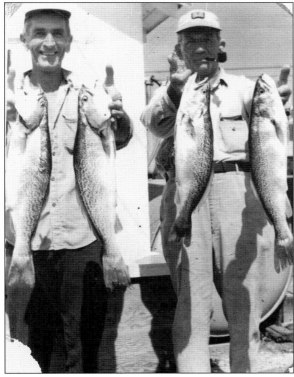

Here in 1950 are Captains Edward (Ned) Gandy and Clifford (Cliff) Finley; they are only too happy to show off the catch of the day. The two men were considered the best there was when it came to fishing for weakfish in Delaware Bay.

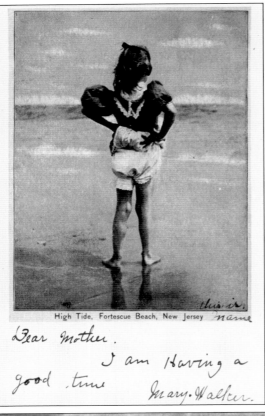

Here in 1905, an unidentified young girl raises her dress as the tide rolls in on Fortescue Beach. The cool water was a delight to young and old alike.

High Tide, Fortescue Beach, New Jersey

Dear Mother. I am Having a good time Mary. Walker.

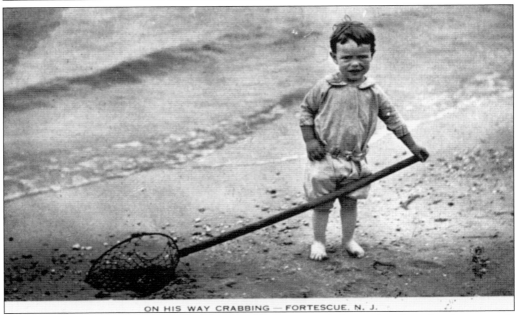

ON HIS WAY CRABBING — FORTESCUE, N. J.

Two-year-old Alfred "Cuddle" Rammell plays with a net much larger than him, hoping to catch a crab or fish on Fortescue Beach in the late 1920s.

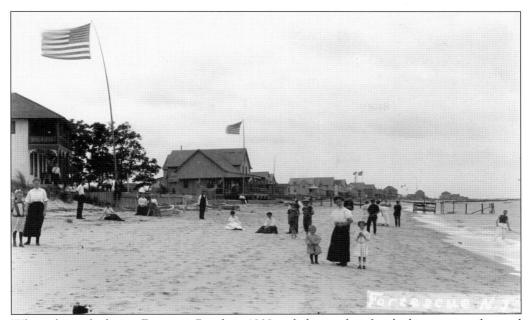

What a leisurely day on Fortescue Beach in 1909, as ladies in their lovely dresses sit in the sand in front of Felmey's General Store as others take a stroll along the bay.

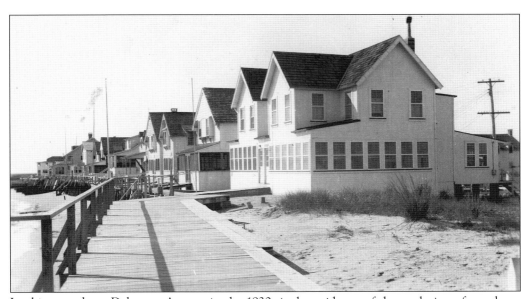

Looking north on Delaware Avenue in the 1930s is the evidence of the explosion of new large summer dwellings. The cottage in the foreground belonged to Joe and Sue Ravis. Finger piers from each house lead to the boardwalk because of undermining due to the extra-high tides.

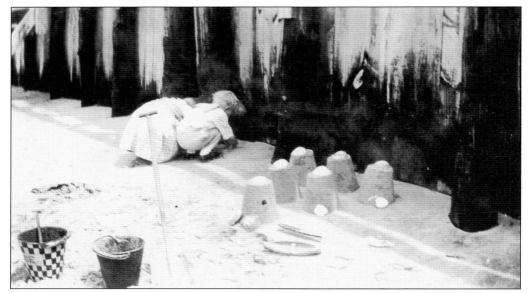

Give a child a bucket and shovel on their favorite beach and watch what they do—of course they will make sand castles. Florence and Fritz Downs are no exception as they build their own town of sand castles on Fortescue Beach in 1920.

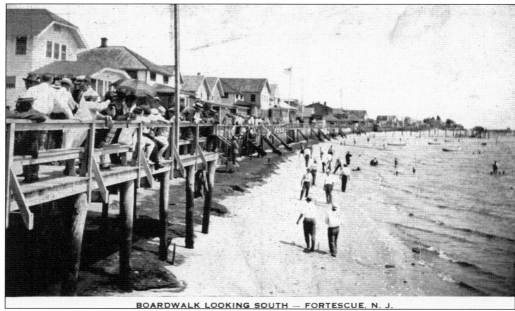

BOARDWALK LOOKING SOUTH — FORTESCUE, N. J.

In 1920, a large crowd of spectators gathers on the northern end of the boardwalk just in front of Oliver and Ida Green's cottage to watch a horseshoe tournament on the beach. It looks like three games are going on simultaneously.

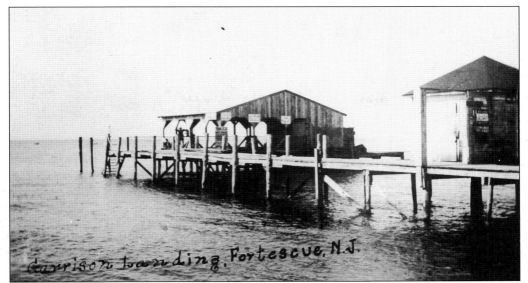

In 1920, Garrisons Landing was used for fueling the fishing boats and buying bait and snacks. When the captain purchased fuel, it was necessary for someone to be on shore to crank the gasoline through the pipe to the pier. Outstretched fingers from the pier indicated how many gallons were needed.

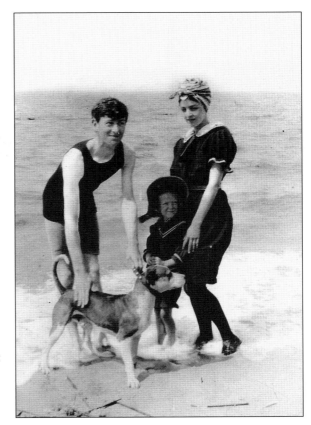

This Foster family photograph was captured in 1906 on Fortescue Beach as they played with their princely mutt in the surf. In the early years, men did not often bare their chests and many women did not bare their legs as they went bathing.

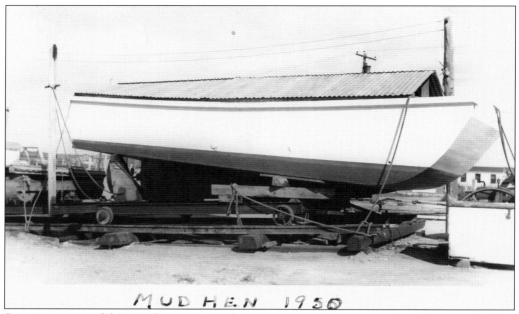

MUD HEN 1950

Sporting a powerful V-8 Palmer engine, this strange craft was designed and built by Clifford Finley and given the name *Mud Hen*. The boat's sole purpose was to push mud and sand that had accumulated over the winter from each dock. The boat is still active after 60 years, with Charles Higbee now at the wheel.

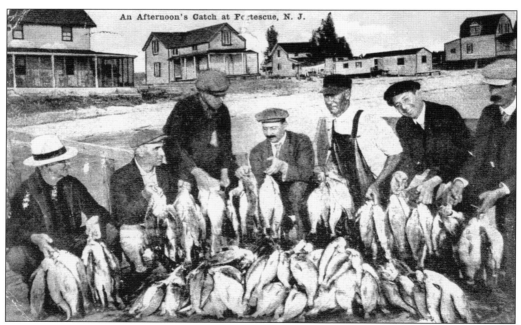

An Afternoon's Catch at Fortescue, N. J.

In 1917, Capt. Charles Gandy, in the white shirt and rubber coveralls, gave his fishing party a very successful trip. It looks like there are enough croakers to feed the entire neighborhood. Captain Gandy was one of the earliest settlers on the island of Fortescue.

Two

LIGHTHOUSES

In 1700, early colonists placed various floating warnings shaped like kegs in the Delaware waters. If the bay was iced over for any length of time they were lost.

In 1793, Pres. George Washington approved a contract for a floating beacon with two masts and kegs for the Delaware River at a cost of $264. By 1873, a lightship was established at Cross Ledge and Fourteen augmented by various nun, can, and spar buoys. The midbay channel must be followed by ships in order to find sufficient waters. Lighthouses became the permanent solution at critical locations in the Delaware Bay. There are no more manned lighthouses, as today they are automated with the historical society helping with the maintenance and their beautification.

The lighthouses from north to south are Ship John off the Cohansey River, named after the ship *John* that sank near the spot in 1797; the Elbow of Cross Ledge established in 1901 as a gas buoy; and Cross Ledge, nicknamed the Old House by fishermen who fish at its base everyday. Just before World War II, the old house was abandoned and used as a bombing target. On target practice days, the fishing vessels were only allowed to fish way up or down the bay, not out front. Today the base of the old house is only good for hundreds of seagulls to perch on. Miah Maul was established in 1913 midway between Fourteen Foot Bank and the Elbow of Cross Ledge Light, to mark dangerous shoal of the same name on the New Jersey side of the main ship channel. Brandywine Light is located in the southernmost part of the Delaware Bay. This was the last lighthouse in the bay to have a keeper. It is still an important aid to navigation.

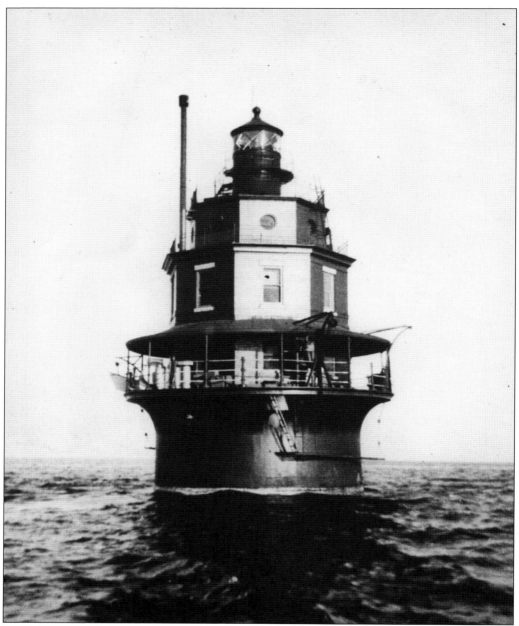

In 1901, the Elbow of Cross Ledge was only a gas buoy. In 1907, a lighthouse was established. When completed in 1910, with a permanent light and fog signal, it looked much like Miah Maul except the dwelling was octagonal instead of circular. It has been said that the Elbow, which has been abandoned, was too far inside the shoal and did not serve the best purpose. It was an octagonal dwelling with quarters for three keepers.

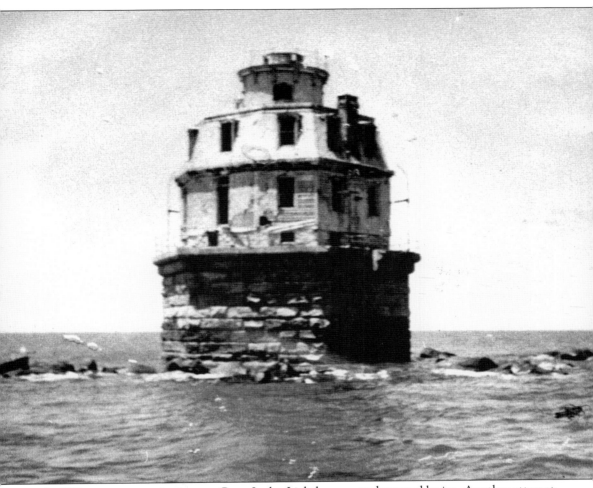

In 1823, an attempt to construct Cross Ledge Lighthouse was destroyed by ice. Another attempt in 1855 was made, and in 1856, the ice won again. In the meantime, lightships were used to mark the shoal. In 1875, efforts were successful and the lighthouse was established. During World War II, the abandoned lighthouse was used for target practice by pilots undergoing training for the war.

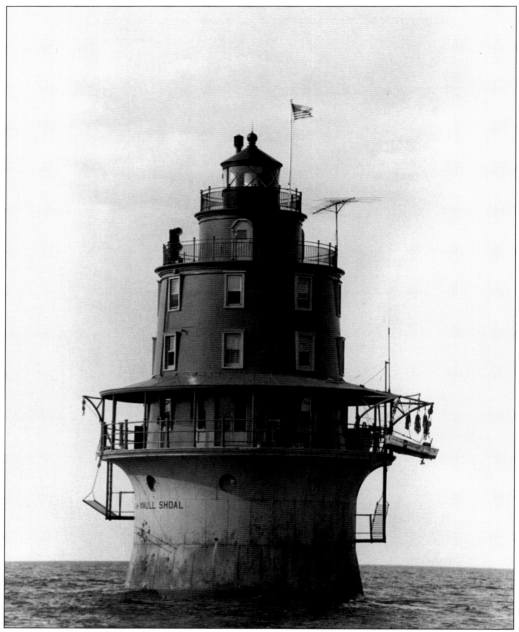

In 1913, Miah Maul Shoal Light Station was established to mark a dangerous shoal on the New Jersey side of the main shipping channel in the Delaware Bay. The three-story circular dwelling of cast iron was assembled on shore and towed out to the site and sunk on 187 oak pilings, each 14 inches thick.

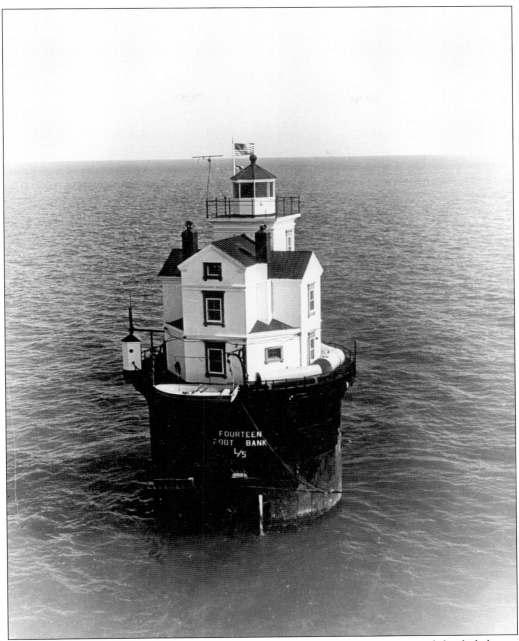

In 1886, Fourteen Foot Bank Light was built using a new screw-pile structure and this lighthouse replaced the lightships. In 1888, the screw-pile structure was replaced by a caisson structure sunk in the sand bottom by a pneumatic process and relit in 1889. This was the first lighthouse in the United States built on a submarine foundation.

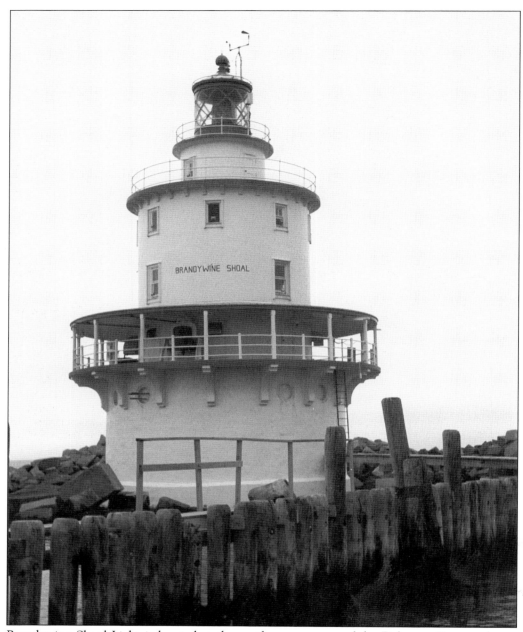

Brandywine Shoal Light is located at the southernmost part of the Delaware Bay, northwest of Cape May Point. It was the first screw-pile lighthouse ever built in the United Sates. The brilliant lens shone for the first time in 1850. After serving for 60 years, a new conical structure was built on a caisson of concrete and lit in 1914. Brandywine was the last lighthouse to have a keeper on board. Automation took place in 1974. It was a sad end to a proud era.

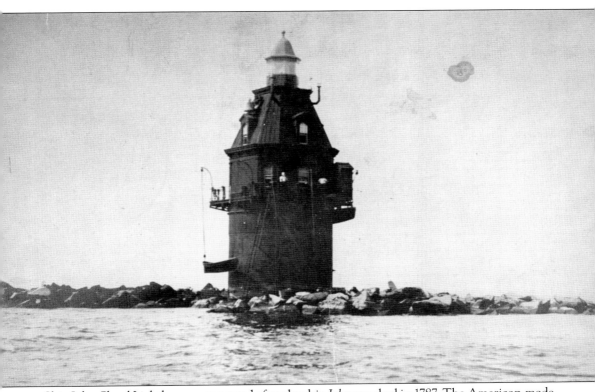

Ship John Shoal Lighthouse was named after the ship *John* wrecked in 1787. The American-made vessel was built in Newburyport, Massachusetts, but was freighted from Hamburg, Germany, for Philadelphia. The lighthouse was placed near the site of the wreck located in the northern part of the bay near the mouth of the Cohansey River in 1877. The beacon was fully automated in 1973 and is still a working guide for navigation today.

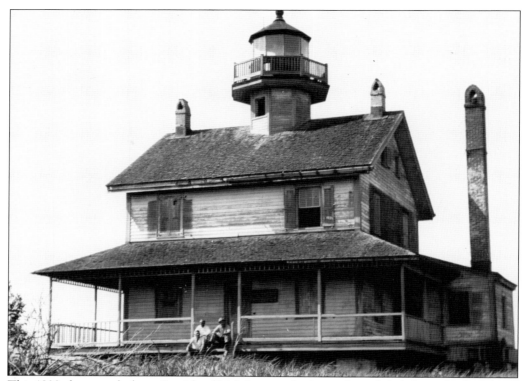

This 1838 photograph shows Egg Island Lighthouse, which was the only lighthouse built on land, at the southern tip of Fortescue. The two-story structure contained a kerosene light. Rebuilt in 1870 and abandoned in 1940, the manned lighthouse was replaced with a light on a tank tower. In 1950, it was burned to the ground by fishermen finding refuge from a storm. Why they had to build a fire in the center of the room instead one of the three fireplaces is still a mystery today.

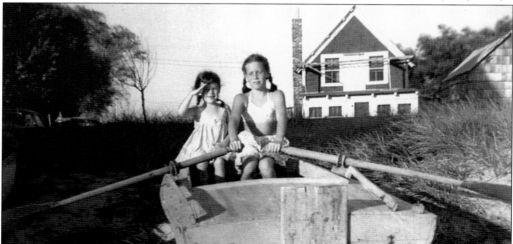

In 1941, Patricia Godown salutes as Carole Reiley pretends to row in their grandfather Preston Foster's wooden boat on Fortescue Beach. Reiley was loved and known by everyone as the "lighthouse lady." Being a lighthouse historian, she was able to set up lighthouse tours to the delight of many people.

Three

MARINAS

During the 1900s, there seemed to be a need for small boat rentals as the word got around that fish were being caught close to shore in great abundance. Soon a dozen or more rowboat marinas were beginning to spring up in town to meet the demand. Oars were the only source of power for awhile, and then motors came on the scene, starting at 2.5 horsepower. The horsepower steadily grew, first to 5, then 7.5, and finally 10-horsepower engines were used. This seemed pretty fast to someone who only a few years ago was using oars. The rental marinas became very popular with the public, so popular in fact it became necessary to call and reserve a boat to ensure there would be a boat upon arrival. As with many things, soon the rental boat business started to fade away. In November 2006, that part of history in Fortescue came to an end when Elizabeth (Liz) Cowley of Hook, Line and Sinker closed its doors.

Listed are some of the rental marinas that helped foster a great family tradition. From north to south, on Downe Avenue, the marinas were Joe Oley's; Bill Tubman's; Clifford and Bertha Finley's; and Bunky and Betty Higbee's. On State Road, the marinas were Double A, Al Currant; Alvin and Francis Lucas; Martha Williams; Hewitts; Rockets; William Anderson; Jim Miller with Lana; and Gary Borkowsky. On Delaware Avenue the marinas were Erwin and Jane Meyers; Matthew and Helen Pringels; and Tom Russick. On New Jersey Avenue there was the pavilion; Hundermarks; Ed Lockner; John Reynolds; Lou and Hazel Pattasani; Robert Wolf and George Joyce; Bet and Bud's, Lawrence and Betty Pharo; Millers, Samuel and Helen Miller; Tug Boat Annie's, Edward and Ann Senecal; Walter Rhubarts; Carrs, Charles and Florence Carluzzo; Phil Hopleys; Yellow Bird, Joe and Gladys Esposito; Hook, Line and Sinker, Elizabeth Cowley; and Francis "Pie" Pugh. On Raybins Beach there were Sanders, Leonard and Gertrude Sanders; Horns, Gus Horn; and Budd Dares.

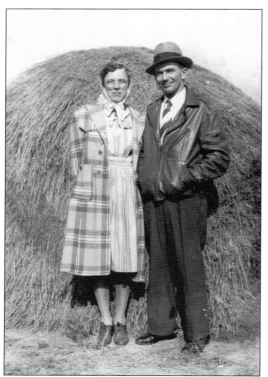

In the 1930s, Clifford and Bertha Finley left their farm in Deerfield to become marina owners. Upon the death of Bill Tubman, the Finleys purchased Tubman's Boat Rentals and renamed it Finley's Boat Basin. The Finleys worked as a team and rented boats for many years.

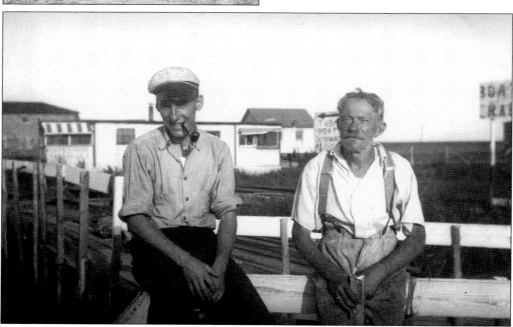

Old salts Fred Kurtz and Bill Tubman are pictured enjoying a warm, sunny afternoon waiting for the rental boats to come back in during the 1930s. Tubman, the owner of Tubman Boat Rentals, had the houseboat in the background made into his permanent home on land in the early 1930s. The house was located on Downe Avenue at the bridge.

Resting in their slips for the night are the wooden handcrafted boats for hire, owned by Clifford Finley of Finley's Boat Basin. The *Margaret M.* belonging to Capt. Albert Fralinger of Bridgeton can be seen hoisted up on the old wooden railway, ready to be serviced. Other boats on land are the *Sea Gull* and the *Mary* from Camden. Laundry hangs clear around the Finley building, and a sign reads, "Warning Clean No Fish in Boats." The small house across Downe Avenue is the original Higbee home. It was later moved to Laura Avenue and is the home of the Strawberry Burnight family.

This railway was built by hand in 1945 by Clifford Finley. It was much needed for the larger party boats to be removed from the water and worked on. The boat *Conesta* was the first vessel to be pulled on the railway by a Hettinger engine in 1946. A large lift has replaced the railway.

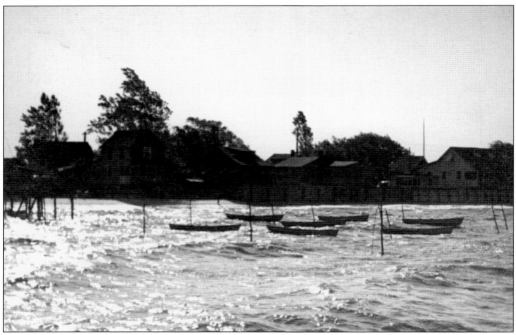

This view of Fortescue Beach in 1946 shows the rental boats of Walter Rhubart tied at their stakes near the Municipal Pier. The boats rode the waves waiting for sportsmen to arrive in the early morning. Upon Rhubart's retirement, his boats were sold to Lawrence "Bud" Pharo.

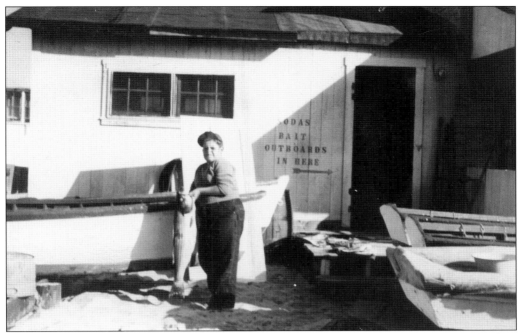

Standing at his parents' rowboat marina, Bet and Bud's, Larry Pharo Jr. proudly displays a 21.5-pound striper he caught at the age of 14. Today Pharo is captain of the charter boat *Judy Ann*.

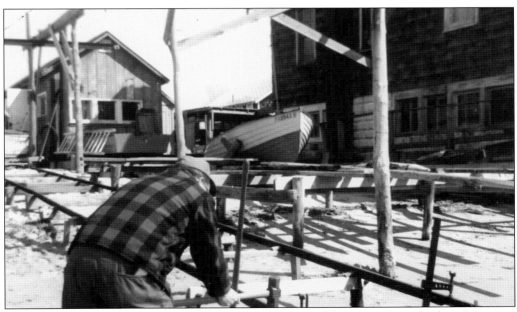

Bet and Bud's Rentals had tracks that carried their rental boats out into the bay. Lawrence "Bud" Pharo purchased his boats from Walter Rhubart's marina upon Rhubart's retirement. The land was purchased after the 1950s flood destroyed Hoppy's Seagull restaurant next to the Charlesworth Hotel.

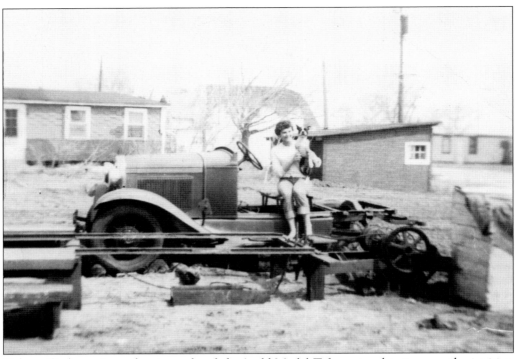

Deloras Carluzzo sits and waits on her father's old Model T for a signal to turn on the ignition and pull a rental boat from the bay up a railway that has a cable tied to the rear axel. The picture below is another look at Carr's marina owners Charles and Florence "Mickey" Carluzzo. The Model T from the photograph above is in the center. The two-story building with a porch across the street is the popular speakeasy Gray Goose.

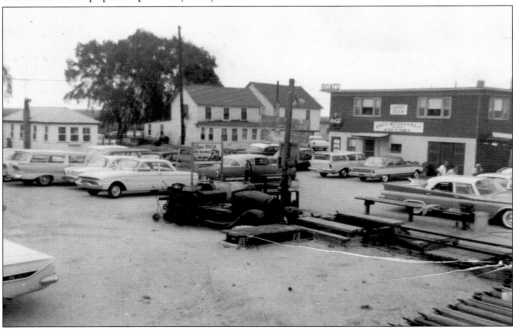

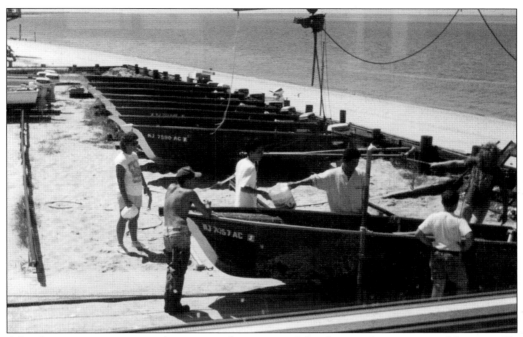

After having many owners, this marina, being one of the first on the scene, would eventually become Hook, Line and Sinker under the direction of Elizabeth (Liz) Crowley and also be the last small boat rental on the scene.

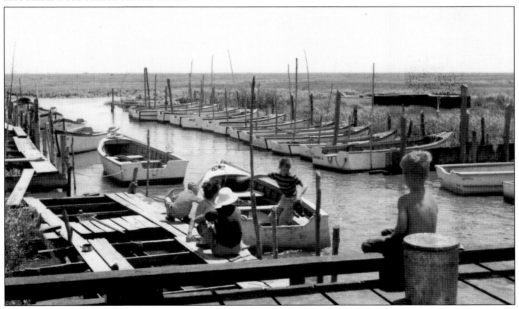

Leonard and Gertrude Sanders owned one of the largest boat rental facilities on Fortescue Island. It was situated on both sides of the bridge crossing Oyster Gut, in the area known as Raybins Beach. This photograph shows the boats moored on the creek side for safe harboring. In the morning they were taken under the bridge to the bay side and readied with a motor for rental. Gus Horn's boat rental was located next to Sanders on the bay side.

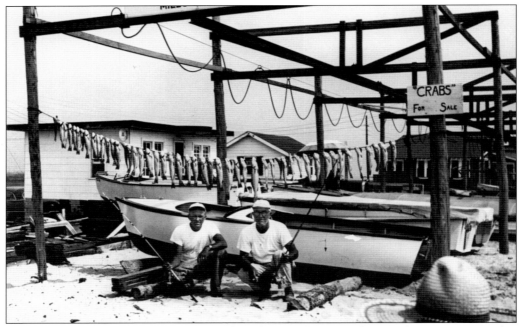

Earl Denver and Charles Lynch show off their day's catch from Miles Gandy Marina at Gandy's Beach. Weakfish were very plentiful in this era, and many made a good living from them. Weakfish got their name because their jaws are weak, causing the hook to pull through.

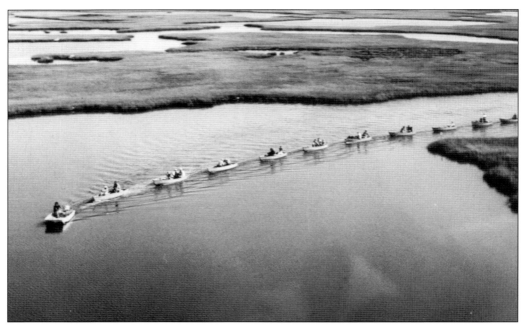

Crabbers are being towed from the docks to crabbing areas at Beaver Dam, which is near Dividing Creek. When customers rent a boat they get towed out. Later in the day they are picked back up. People have been enjoying crabbing this way since the early 1920s. Owners Paul and Linda Waterman also offer kayaking and canoeing.

Four

FOOD AND LODGING

During the early 1900s, Fortescue was beginning to explode with hoards of fishermen and vacationers. They slept in their cars or pitched tents. A great need of housing, overnight lodging, and eating establishments was about to be filled. Many of the fishermen who lived and traveled in houseboats began to build permanent cottages for their families. Luxurious inns, lodges, and hotels began to emerge on the island. More people were being lured into Fortescue by great food, mainly seafood, than by fishing. Such dishes as fresh fish, clam chowder, oysters, duck, muskrat, and the popular Fortescue fries were all favorites.

Meals were served family style. Menus included minced meat pies from muskrat and scrapple made from croakers. Lucius Bradford would supply the restaurants with ducks. Tony Ogden supplied the ice cut from Cedarville Pond. The butcher was Harry Chance from Dividing Creek. Ross Bacon delivered baked goods to the restaurants. Two hucksters, Morton Bradford and his daughter Lulu, and Mr. and Mrs. Tyler Lore, delivered fresh produce.

Some of these restaurants for fine dining and comfort lodging were the Hotel Charlesworth, Fortescue House, Weber House, Dew Drop Inn, Mayflower, Hoppy's Seagull, Loper's Municipal Hotel, Sam and Kate's Hotel, Garrison House, Garrison Lodge, Fortescue Hotel, Hundermarks, Williams Hotel, and the Charles Day House. All have disappeared from the scene, leaving their mark on history with fond memories—all except the Charlesworth Hotel, which has stood the test of time and still stands tall as testimony of what a captivating time it must have been.

When Ruella Charlesworth had the hotel built in 1925, she commissioned Thomas Pugh as the carpenter. H. H. Hankins and Brothers of Bridgeton supplied the needed materials, which were barged down the Cohansey River. Frank Hankins says there was much lumber needed for all the building going on, so his father decided to rent a piece of property in Fortescue and start a lumberyard, which existed as long as the building boom continued. The barge would be filled with lumber and land on the beach, and Frank as a child helped his father push it off and then carry the lumber to the fenced-in area.

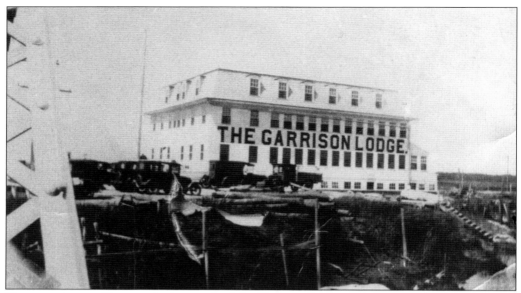

The conspicuous Garrison Lodge was built by Herbert Garrison along the left creek bank just before crossing the bridge onto Fortescue Island. This was Garrison's third and most contentious structure. He built it during a time when the bay resort craze began to wane. Dismayed over a $1,200 tax bill, Garrison ordered the impressive three-story lodge torn down. The building was not even three years old.

This snapshot captures Florence May with her brother Boyd entering the dining room on the first floor of the Mayflower Inn. The Mayflower Inn and Restaurant was owned by Clifford and Stella May.

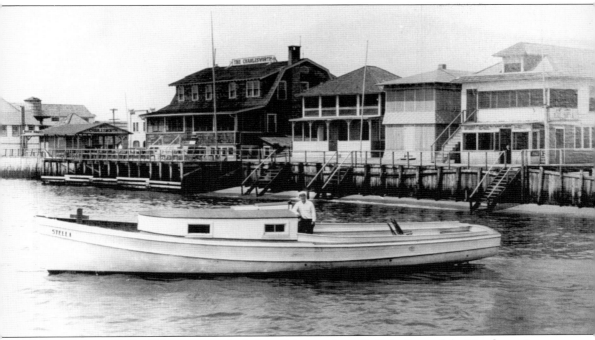

In 1929, Capt. Clifford May poses at the helm of his party boat *Stella* in front of the Mayflower Inn and Restaurant. The 40-foot-long boat was built in Dorchester and named for his wife. Clifford and Stella owned and operated the Mayflower enterprise. The captain made sure the restaurant had fresh seafood daily. The first building on the right is the Mayflower Inn and Restaurant. The fourth building from the right is the Charlesworth hotel and restaurant. (Courtesy of K. Ryan.)

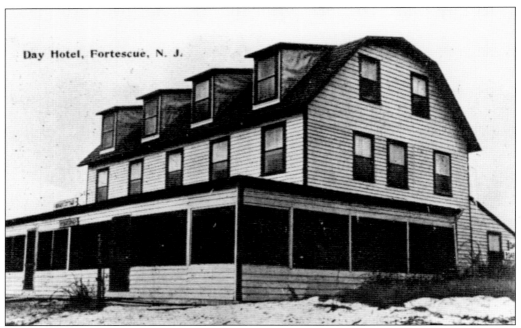

The Day Hotel featured an impressive beachfront and a popular restaurant. It was built by Charles Day in 1920, and visitors enjoyed watching the colorful sunsets from the wraparound screened-in porch. A favorite menu item from the restaurant was the muskrat minced meat pie.

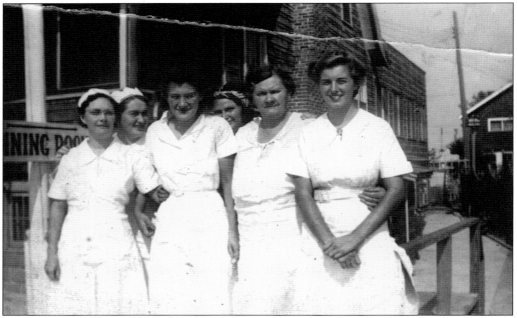

Six of the original waitresses pose on the deck of the Hotel Charlesworth just before reporting for work. The lovely ladies in starched white uniforms are, from left to right, Francis DuBois, Elinor Wheaton, Elizabeth Henderson, Anna Dopirak, Helen Derecky, and Elaine Girard Van Parys.

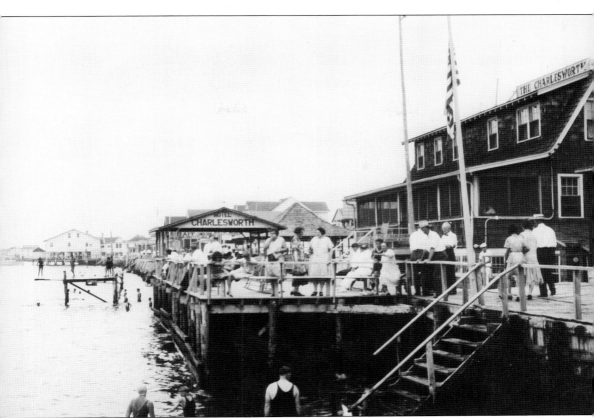

Ruella Charlesworth of Bridgeton had the Hotel Charlesworth constructed in 1925. After the death of Charlesworth, the restaurant went under new management for a short period as the Johnson House and later as the Preston Restaurant. A bakery was down in the basement before it was a restaurant. When Fortescue began to thrive, Philadelphians would fill the 10-room hotel, which had no indoor plumbing, and sleep on cots. When Phyllis Tulin and her husband Ennio purchased the hotel after the 1950 flood, it then assumed the original name Hotel Charlesworth. When Phyllis retired, her daughter Phyllis and son-in-law Tom Hunt became the new owners, nearly losing it all to Mother Nature again in 1980. Tom was able to repair the damage, and the hotel won again. Current owners Jim and Shirley Fonash have kept the same majestic atmosphere as people were used to when dining in Fortescue. They are still using the same loaf pans Ruella used in 1925. The Hotel Charlesworth is the last of the old grand hotels to remind people of the luster that used to be.

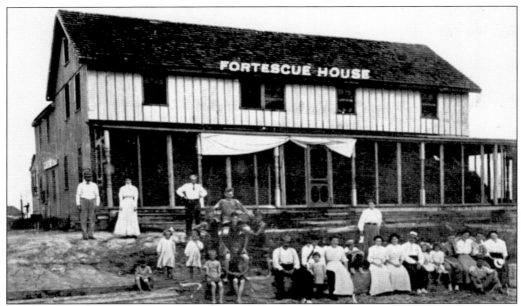

In 1907, the Fortescue House was a spectacular three-and-half-story building owned by Herbert Garrison. It consisted of 18 large rooms. The hotel was built on the beachfront with a heavy stone wall for protection from the raging bay. It boasted the first artesian well with clear flowing water.

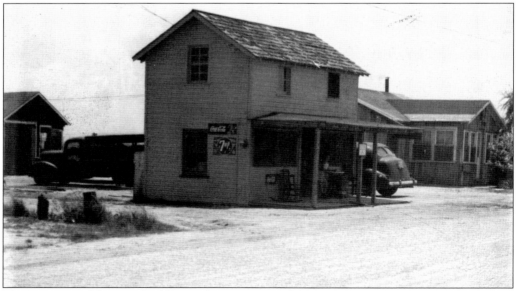

This picture is of the same building as the one on top of the opposite page. Only a few years earlier, the porch has not yet been enclosed, but it is open for business. In the lower picture on page 61, years later, 15-year-old Mildred, who would later become Mildred Higbee, mother of Clarence "Bunky" Higbee, is standing next to Jess and Jeanette Cossaboon, soon to be grandparents.

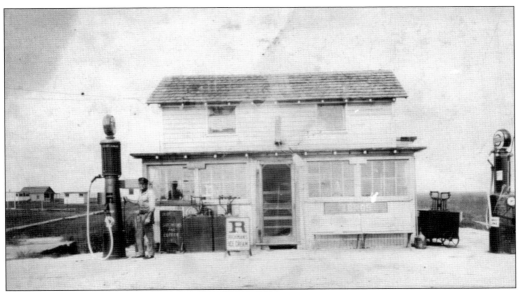

In 1920, the luncheonette and gas station (above) situated on Downe Avenue belonged to Capt. Jess Cossaboon and his wife Jeanette. They sold Standard gasoline and motor oil. The pump says 18¢ a gallon. Later on, this building was moved to Garrison Avenue and became home to Lillian Hamilton's variety and grocery store. The photograph below shows the interior of the general store with the proprietors and their daughter behind the counter. Pictured from left to right are Mildred, Captain Jess, and Jeanette. The clientele could purchase Cherry Blossom sodas for 5¢, Tennyson cigars at 5¢, three flavors of Richman's Ice Cream—vanilla, chocolate, or strawberry—and sandwiches for 25¢ each. The calendar reads July 1930. Folks may remember that the old bait truck owned by Captain Jess made three trips a week to Cape May to buy bait.

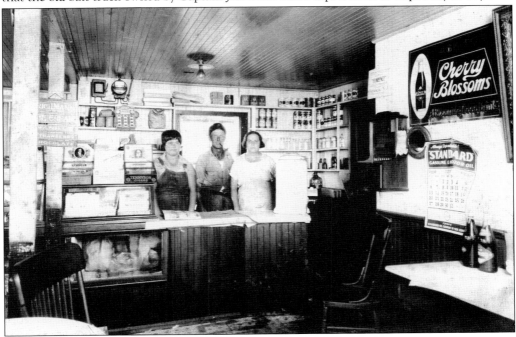

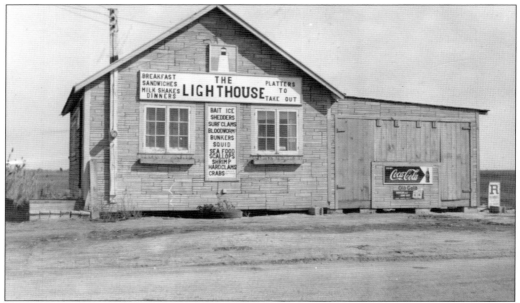

The Light House restaurant and bait shop used to be located on the left side of Downe Avenue. It was the former home of Clifford and Bertha Finley, the home they lived in when they first moved to Fortescue in the early 1940s when they bought the marina. New owners Frank and Delores Rodenbaugh had an extensive menu for such a small building, as the billboard on the wall details. With its home cooking, this was a very busy place for lunch and suppers. Clarence and Betty Higbee would become the new owners, and this became Higbee's first luncheonette (below), which is now located across the street. The location of the building in the picture is now a large boat parking lot.

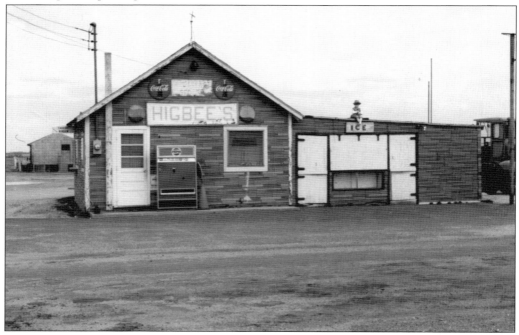

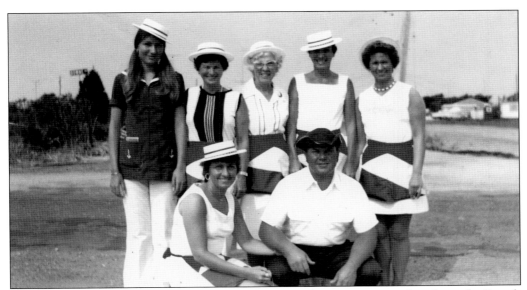

The work crew at Higbee's restaurant prepared to serve their customers with style on the Fourth of July back in the 1970s. Pictured from left to right are (first row) proprietor Betty Higbee and Ronald Loper; (second row) Cynthia Higbee Fuller, Anna Robinson, Bertha Finley, Joan Berstler, and Marilee Higbee.

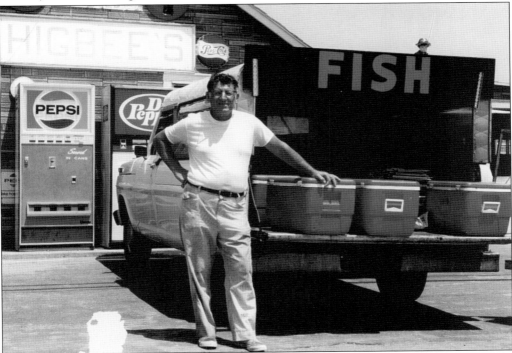

The bellowing sound of "fresh fish for sale" echoed throughout the island by Frank "Reds" Notaro. Reds could be found seven days a week all summer long in front of Higbee's marina. No matter how unlucky one's day of fishing was, Reds always made sure there was fresh fish available to take home to the family.

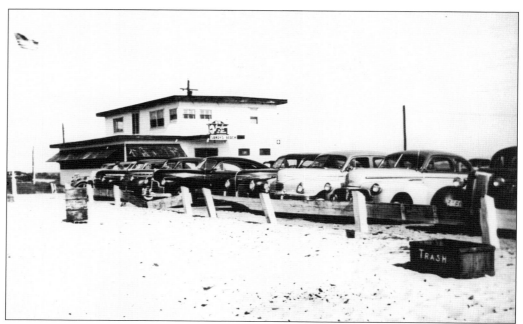

Vernon Keller's luncheonette on Gandy's Beach was a great place to get a delicious sandwich and a cold drink on a hot day. It was enjoyed by residents and fishermen alike.

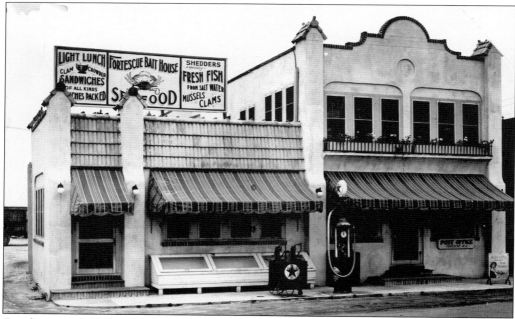

On the corner of New Jersey and Downe Avenues, Thomas Pugh constructed this two-story general store and post office of stucco with a Spanish motif around 1920. This was a welcome change for the residents. In later years it was owned by the Zurlo family and called the Family Fruit. Many people considered the property a historic landmark, but it was leveled by Thomas Hunt, then the owner of the Hotel Charlesworth, for a much-needed parking lot. Other owners were Sam and Kate Engles and Joe and Dorothy Klosterman, from 1939 to 1965.

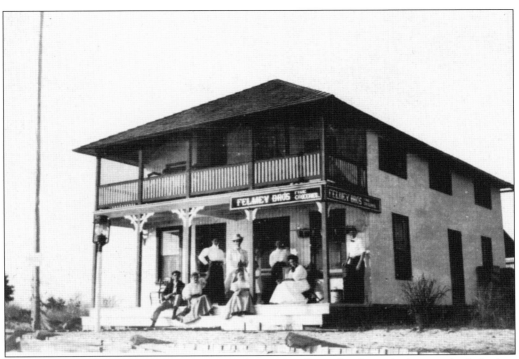

Above in 1908, the Felmey Brothers general store is where the first telephone, which had to be cranked by hand, was located. This was where the captains would receive their charters. Needless to say, the captains stayed on the storekeeper's good side. Captains checked in every morning. By 1910, in the picture below, another general store and ice-cream parlor would be built next door. A person wrote on a postcard, "Come on down there seems to be 500 hotels here now, more or less."

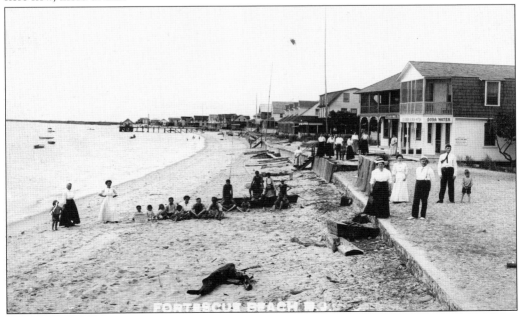

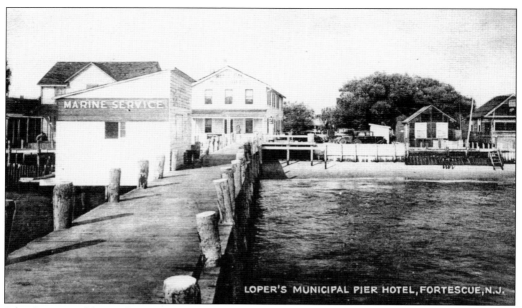

LOPER'S MUNICIPAL PIER HOTEL, FORTESCUE, N.J.

John Loper and his wife Anna Porter Loper (below) built the Municipal Pier and Hotel (above) in 1938. On the bay side was a marine service shop that sported a massive 330-foot pier that stretched out into the bay. On the New Jersey Avenue side, patrons entered the hotel and restaurant. This popular fishing pier was destroyed by fire in 1963.

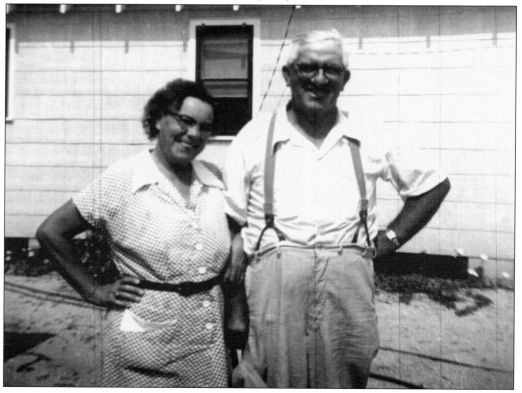

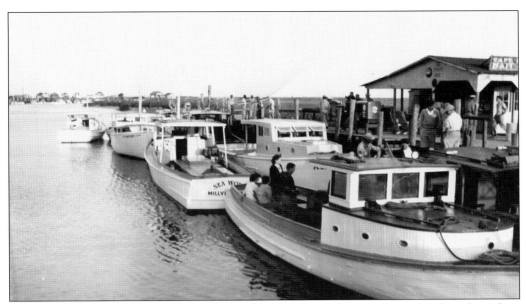

In the 1930s and 1940s, before docks were built along the creek, party boats lined up three deep at Downe's Bait and Tackle shop by the bridge. Customers had to walk from boat to boat to get to the one they chartered. Much maneuvering was necessary to leave first or get gas.

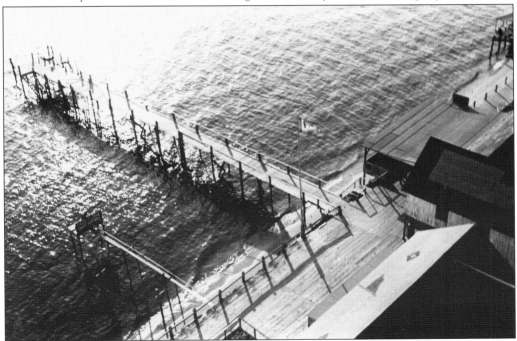

The famous Hundermarks Pier extended 300 feet into the bay. Prior to the present-day marinas, the captains anchored their boats safely in the creek, but they had no way to load their passengers on their vessels. They used the beachfront piers to comfortably pick up and return their patrons to shore. Boats often tied up to the piers to allow their travelers to eat in the choice restaurants. The long piers are nonexistent today due to the high winds, tides, and ice flows.

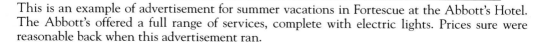

This is an example of advertisement for summer vacations in Fortescue at the Abbott's Hotel. The Abbott's offered a full range of services, complete with electric lights. Prices sure were reasonable back when this advertisement ran.

Five

NATURE'S HARVEST

Fortescue grew slowly and naturally on its natural resources and not by luring the affluent with high-priced homes and malls. Over half the island has extensive salt marshes alive with wildlife, making the duck and goose hunters delighted. Trappers trudge across the cold meadows in pursuit of the furry muskrat and dine on their sweet brown meat and sell the furs for much-needed winter funds. The bay provides an abundance of natural wonders, helping young captains to still do what their ancestors did years before. Jim, Clifford, and Charles Higbee are fourth-generation captains. Joe Ronketty Jr. and Thomas Ronketty are fifth-generation captains. Joe Maffie and Rick Warren are third-generation captains. These very ambitious, weather-beaten young captains can still sail the Delaware Bay and catch enough different species of fish to please anyone's pallet. Longtime grabbers John Bradford and Theodore (Teddy) Derecky take to the bay every day, no matter what the weather, from early spring to late fall in hopes of catching one of nature's wonders—the elusive crab. Bait and tackle shops depend on the shedder crabs for fishing bait. In the summer, when outside picnics become popular, people begin to have a passion for the luscious crustacean with a flat body and 10 legs. These all-around waterman not only crab fish but harvest other of nature's wonders, conchs, eels, fish, and oysters.

Fortescue's natural white sandy beaches are one of nature's finest accomplishments. Due to the easy accessibility, retired and low-income families seem to be quite satisfied with the conditions the way they are now, while in other areas of New Jersey access to sandy beaches is being limited or tag access only, which in some cases is forcing people away from their shores. Unless some unforeseeable changes are made, Fortescue will continue to be a place were people can enjoy and touch nature's wonders free of charge.

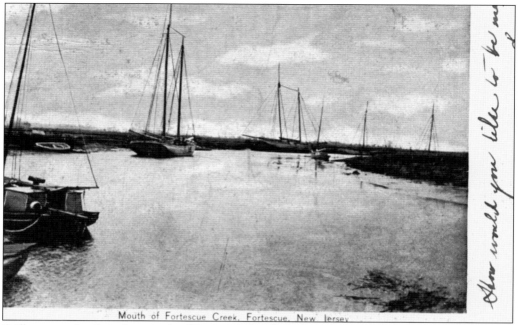

Mouth of Fortescue Creek, Fortescue, New Jersey

Sailboats used to line the mouth of Fortescue Creek in 1905. A small yawl boat lies on the bank for the captain to row out to the sailing vessel. If there was no wind to fill the sails, a yawl boat would be used to push the sailing vessel.

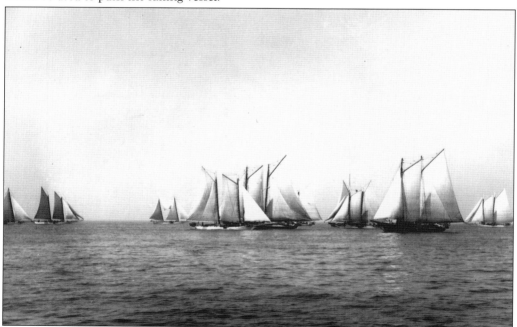

The 1929 oyster schooner race was inspired by the world's largest and best schooners ever to work the Delaware Bay. Boats participating in the race could only use the same amount of sails used during the planting season of May and June. The race was arranged so spectators could see the fantastic race from the Fortescue shoreline.

This photograph taken in 1915 shows a very busy day on Delaware Bay. On the right, boats prepare to leave the pier. Out on the water, oyster boats under billowing white sails and powerboats manned by eager fishermen hope to reap the bay's delicious bounty.

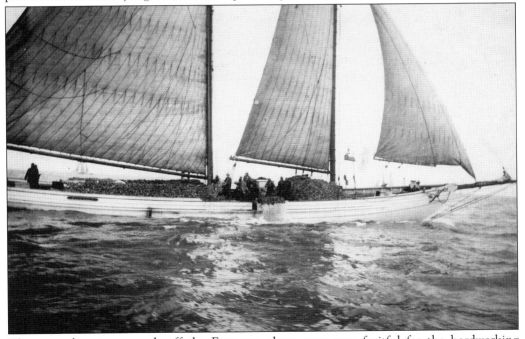

The natural oyster grounds off the Fortescue shore were very fruitful for the hardworking oystermen. This schooner with its large white billowing sails has its decks loaded and is heading to Bivalve shucking houses in Port Norris to be unloaded.

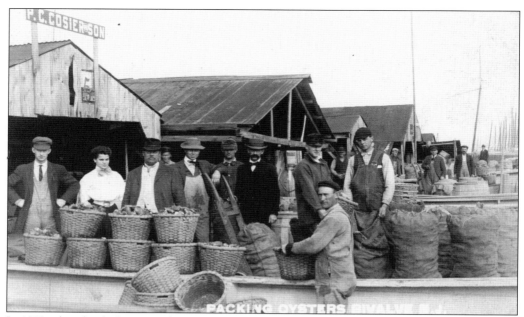

In 1910, a boatload of oysters is being unloaded in Bivalve after a full day of oystering off Fortescue in Delaware Bay. Notice the lovely oyster baskets being used and the wooden oyster barrels in the background. The shucking houses behind them are waiting for their bounty.

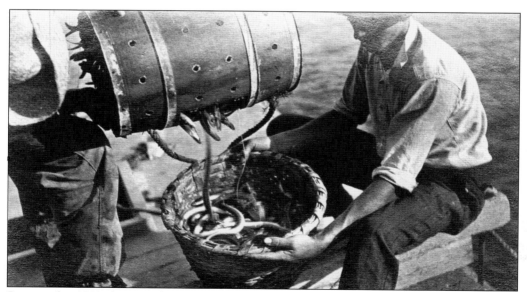

Seen in this 1910 photograph, a barrel of eels is unloaded in an eel basket. Small holes all the same size were placed in the cylinder, so eels that were too small to keep could escape. Eels were used for bait and were also found on Fortescue restaurant menus as a delicacy.

The horseshoe crab, a member of the spider family, is one of Fortescue's majestic wonders. They appear along the beach to lay eggs from May to June. Their eggs are necessary to feed millions of migratory birds. The horseshoe crab blood is also a valuable pharmaceutical chemical. Scientists speculate the species is at least 200 million years old.

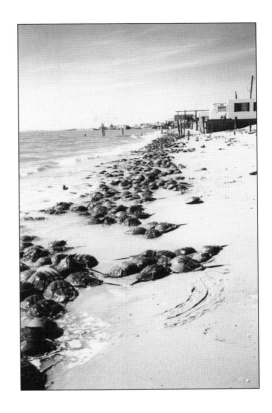

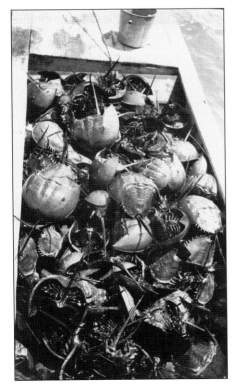

Shown here is a boatload of horseshoe crabs, which are destined to become fertilizer or cut up for eel bait. Six-foot-by-six-foot chicken wire bins were constructed on the beach to hold hundreds of horseshoe crabs until a truck arrived to retrieve them, sometimes cluttering the roadside on the way to their destination. This practice is illegal today.

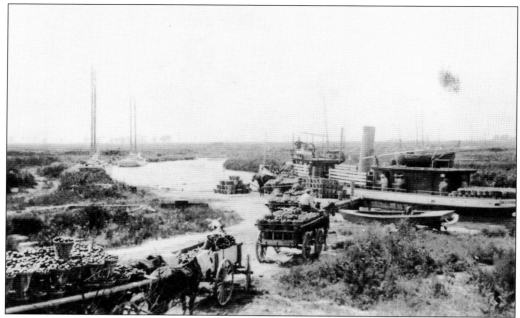

In the 1700s, Autuxit Creek in Newport was used by farmers to transport their produce by steamship to a canning house in Bridgeton or Camden. Today the site is known as Newport Landing, but past names were Autuxit or Agreement Creek and then Nantuxit or Ogdens Creek.

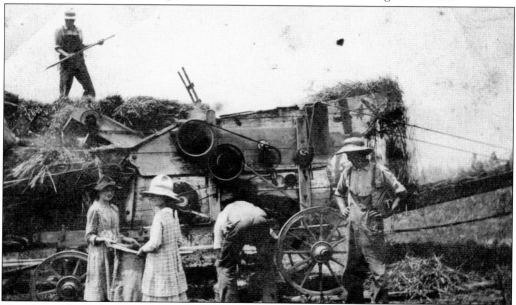

Threshing along the Bay Shore meadows was a profitable business for the hardworking salt hay farmers. The hay had many uses, such as covering early crops, bedding for animals, lining for coffins, and being mixed with mud to make a roadbed. Teams of horses could be seen pulling 10 or 12 hay wagons along the roadside. The resourceful group seen here threshing on a hot summer day in June 1920 includes Earl Casper, Della Carmen, Alberta Casper, Richard Dams, A. J. Casper, and James Cook.

Six

DISASTERS

Fortescue is a small island but certainly not immune to large disasters. The first fire was at the Old Fortescue House, burning down in 1892. In the late 1890s, the Garrison House was destroyed by fire. On Labor Day 1928, eight families were uprooted when fire destroyed their cottages. There were seven wells on the island at that time but no means of pumping water. In 1943, the Hundermarks Hotel was destroyed by fire. In 1963, a fire erupted, called the "Big One" because of the massive destruction caused by a smoldering barge and the wind sweeping smoldering ambers into a cottage belonging to Edward and Ann Senecal, causing a fire that swept down New Jersey Avenue on both sides destroying half the town. In 2007, another fire with high winds erupted, but due to new modern equipment, thankfully only two cottages were lost.

Floods are Fortescue's greatest fear. In 1950, a flood of major proportions nearly destroyed all the towns along the Delaware Bay. No homes or property escaped damage. Harold "Had" Weldon and his wife Verna nearly lost their lives when Verna's ankles became tangled in the television antenna wire and pulled her under five feet of water. Harold went underwater to free her and was hit with parts of the boardwalk and busted piers. Inns and hotels were gone or forced to close. In 1980, Helen Cubberly of Deerfield, who owned a cottage at Gandy's Beach, remembers a tidal surge that left the beach community in shambles. There was a no warning until it was too late to leave or for help to arrive. Gandy's Beach luncheonette was totally destroyed, and the marina was almost beyond repair.

Small floods and gales pop up just when one thinks they are in the clear. One year, Dr. Charles Sharp's oyster boat broke loose and a gale blew it onto Fortescue beach. Half of Walter Rhubart's rental boats were swept into the creek during a gale, and all were destroyed.

Living on the water can be a lovely experience or an agonizing one. There were many floods and disasters in the past, and there will be more in the future.

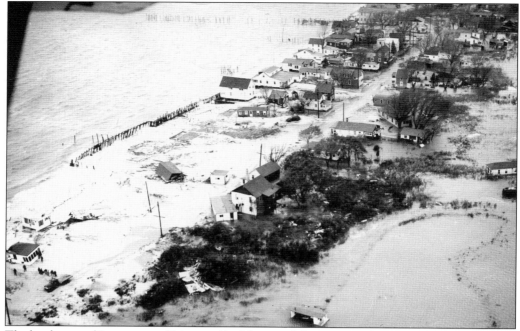

The landscape of Fortescue and historical buildings and the ever-popular boardwalk were changed forever due to the devastating flood of 1950. Structures were left wherever the raging waters decided to place them. This aerial photograph shows buildings scattered every which way.

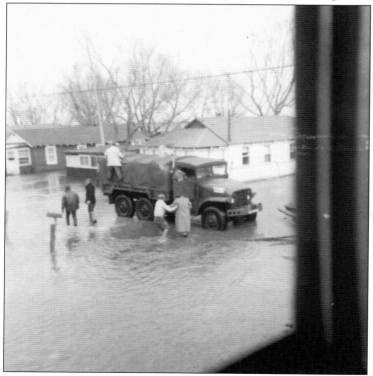

During the flood of 1950, the National Guard arrived in Fortescue to evacuate flood victims from the rising waters. They were taken to the Newport Fire Station and given hot soup and blankets by the Red Cross.

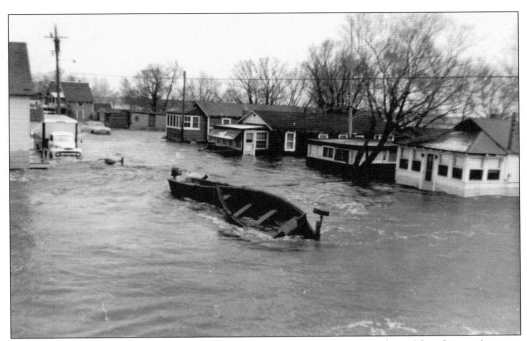

The 1950 flood caused rental boats to batter the home of Bruce French on New Jersey Avenue. The front porch and rental boats were totally destroyed. The water was everywhere, devouring all in its path.

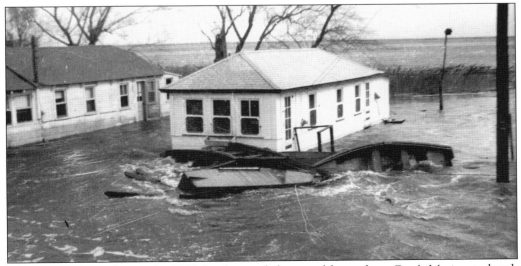

The raging waters during the 1950 flood caused the rental boats from Carr's Marina to break loose from their mooring and rush down New Jersey Avenue, eventually being destroyed.

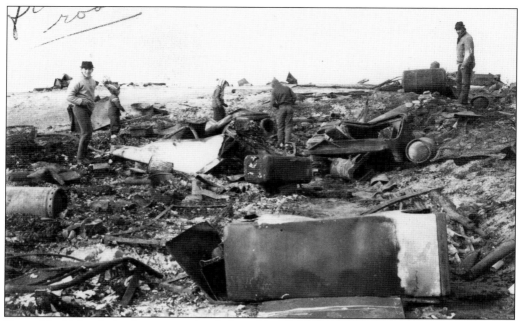

Fanned by high winds, the area was leveled quickly. This picture shows the complete devastation of 23 structures, 17 of which were dwellings. Many residents had to retreat to the bay to avoid the flames that were lapping both sides of New Jersey Avenue. The tragedy left residents stunned and angry.

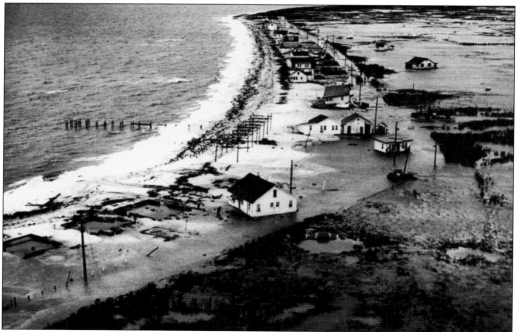

Here is another aerial photograph of the 1950 flood, but this time it is of Gandy's Beach and the devastation there. Houses were removed from their foundations and placed all over. The landscape here would never be the same.

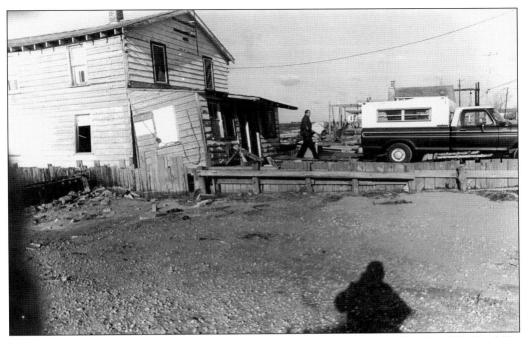

Here is a Fortescue resident on Delaware Avenue next to Myers Marina after the 1980 flood. He hurries as he daringly carries what is still salvageable from his storm-battered home. In just a few short hours the shell of the house fell into the bay.

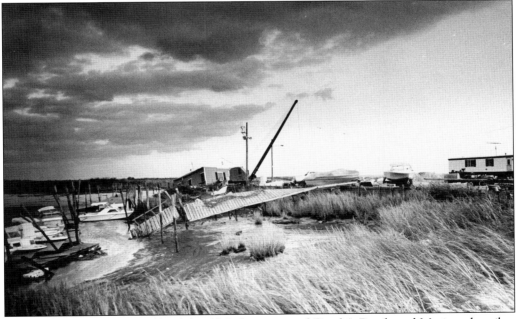

Total destruction is how Richard (Dick) Bobo, owner of Gandy's Beach and Marina, describes the business after the floodwaters rushed through the busy boatyard, destroying everything in their path in 1980. The waters dumped tons of sand on top of the equipment and all around. Dick was able to rebuild and was soon back in business.

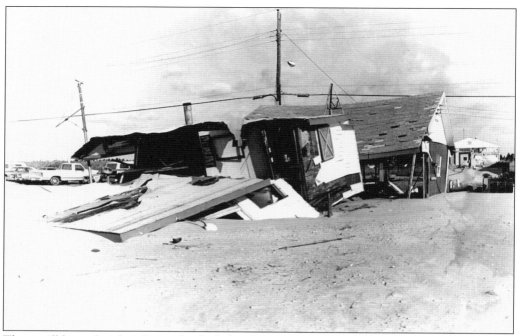

There will be no lunch today at this little luncheonette. It was a longtime landmark in Gandy's Beach. It certainly was not a match for the fury of Saturday's storm in 1980. Like many of the other structures at the beach, it was totally destroyed.

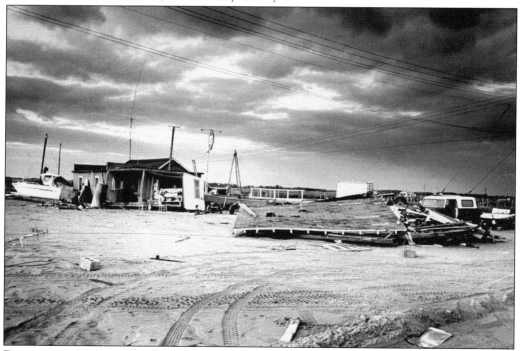

Devastation in Money Island in 1980 is seen in John Pollino's marina. John and his wife narrowly escaped the destruction by jumping into their boat, which was docked at the marina nearby.

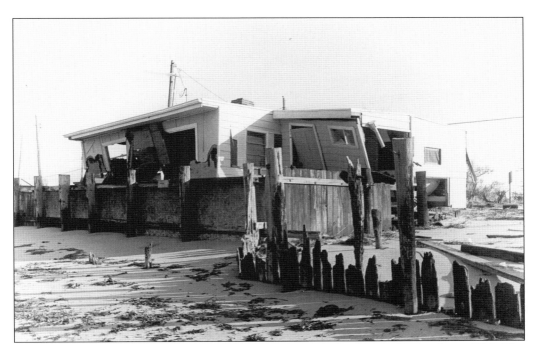

The force of the tide and high winds totaled this cottage on Fortescue Beach in 1980. The empty pilings alongside once held the house next door above perilous waves. These buildings were not salvageable.

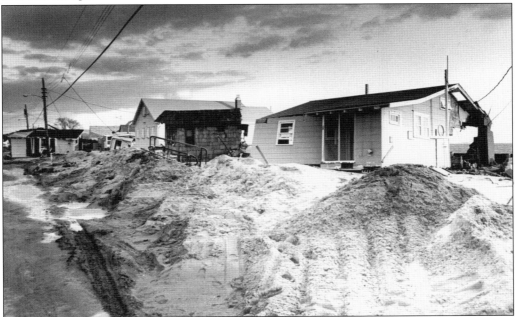

More destruction from the 1980 flood, only shells of summer cottages remain on Cove Road in Gandy's Beach as tidal waters pushed through their interiors, leaving behind tons of sand and debris. A bulldozer had to be brought in to remove houses from the middle of the road in order to make way for the owners to get to their properties.

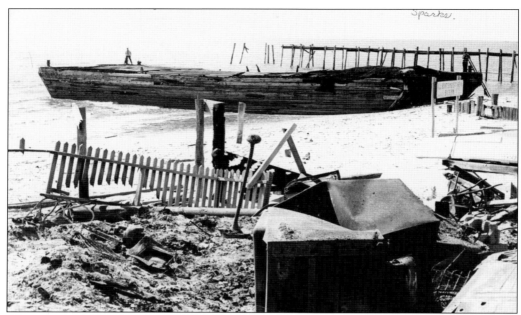

Above is the barge that was oil soaked and set ablaze by Louis Pattasani in 1963. When the high winds came, it blew embers into homes, setting them on fire. Twenty-three structures were totally destroyed. Many residents had to retreat to the bay for safety. The island was in shock, anger, and disbelief. There was a general scene of rubble after the raging fire that took months and months to recover. A dreaded fire hit Fortescue again in December of 2007, the kind that is usually disastrous to old beach homes only six or seven feet apart. And again the winds were at gale force, but due to the modern fire equipment and firemen's extensive training, only two cottages were lost. They belonged to Douglas and Fina Rainear and Walter and Diann Burt.

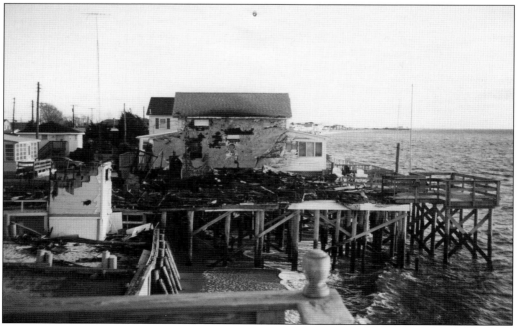

Seven

CABINS, HUNTING, AND SNOW GEESE

Hunting has and always will be an important part of Fortescue. The hunting cabins once dotted the skyline and the meadows edge along the winding creeks. Today there are only about a handful left. All that was needed for a few days of relaxation was wood to keep warm, nonperishable food, a sneak box to get to the cabin, and a good dog. There of course were no telephones or televisions. When the hunter returned home, he made sure food, wood, and fuel for the lanterns were left behind. The cabins were never locked. They became a source of refuge for hunters or trappers who found themselves lost, cold, and hungry. One clear crisp Thanksgiving morning, old-timer Ellis Walker left home in Laurel Lake to do some duck hunting in Fortescue. He arrived at his dock, tied his boat up, and was never seen again. He either had a heart attack or slipped while retrieving supplies from the boat. Days of searching by police divers were to no avail. It was a very sad day for anyone who knew this great hunter. Frank Courtney of Bridgeton became another casualty while hunting. It happened during the 1950 flood when he was unexpectedly caught by the raging waters out in the meadow. His body was not found for two years. Edward Shober was walking the meadows when he spied what he thought was a body, on a large mud bog. Returning back to Fortescue, he called the police. They, along with Oliver "Butch" Green, took a small duck boat and retrieved Courtney's remains.

Today's hunters mostly use a small boat or sneak box covered in reeds or artificial grass. Cabins built in the 1800s still exist. Once they are down, they cannot rebuild per state law. Soon these too will be just a part of history. The trapping of muskrats is almost another nonexistent way of life. Fur prices are low, people are shunning real fur for faux fur, and the meat is illegal to sell.

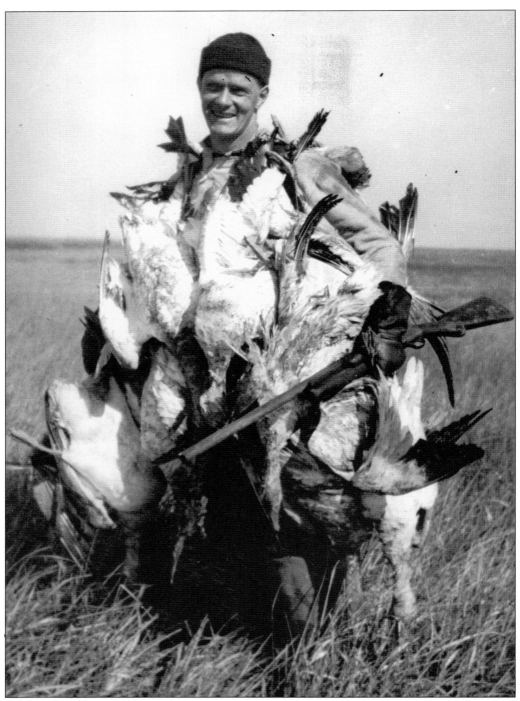

In 1935, Ellis Walker displays a coat of snow geese as he heads back to his hunting cabin on Oranoaken Creek. In later years, Walker would lose his life by drowning at his cabin while preparing to spend the Thanksgiving weekend doing what he loved to do: duck hunt. Sadly, his remains were never recovered.

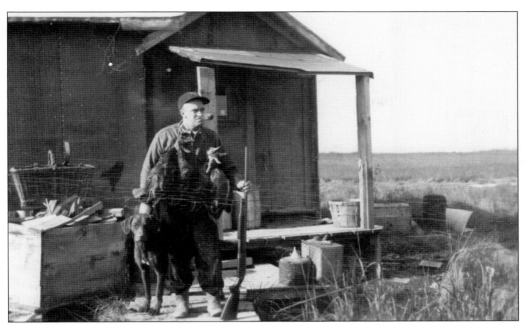

Duck cabins, such as this one owned by Leonard Sanders, used to line the ditches along the marshes. Today there are only a handful of cabins left. The cabins can be repaired but never replaced. Once down, they are down forever. Some early cabin names were Ebner's, Kirchoff's, Snow Goose, W17, Shober's, and Lex Cossaboon's. The earliest cabins were built in the 1800s.

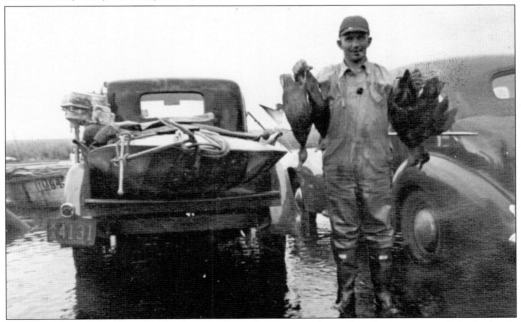

It looks like Clifford Finley had a good day hunting judging by the amount of ducks he is holding and the wide smile on his face. The sneak box in the back of his old truck sports a two-and-a-half-horsepower motor. His favorite place to hunt is the King Pond. Pintails, mallards, baldpates, green-winged teal, blue-winged teal, and black ducks can be found there.

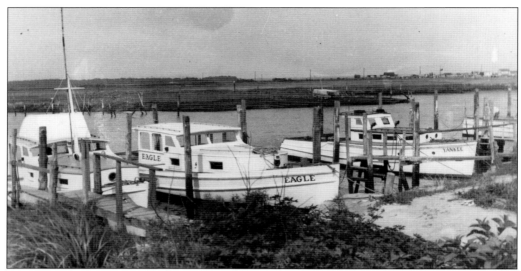

The activity of snow geese watching became so popular the Audubon Society would charter boats for snow geese tours. During the fall season, one could see Capt. Charles Gandy in his boat *Ami* and Capt. Howard Clark in his boat *Eagle* cruising from Beedens Point to Egg Island, staring at the big white birds through binoculars. The snow geese were a great attraction in Fortescue. People would line up and down the roads with tripods to watch thousands upon thousands of snow geese cover the ground so thick it looked like there had been a blizzard. Fortescue is the only known winter refuge in the mid-Atlantic states for snow geese. They were first spotted here in 1934.

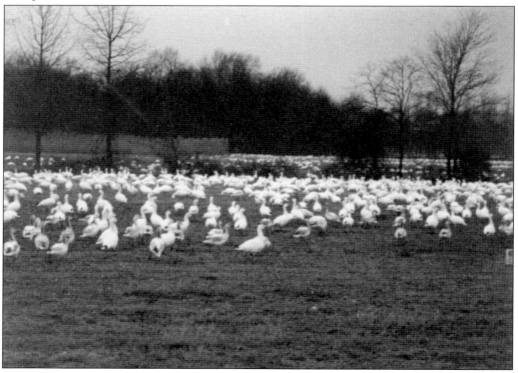

Eight

SIRENS, BELLS, AND HORNS

Arriving in Fortescue in the early 1700s and 1800s was quite a challenge. For years horse-drawn wagons regularly brought people and produce onto the island. During bug season, it was hard on the animals, but people were very proud of their horses and buggies and treated their animals with great respect. At the same time, boats of all shapes and sizes were delivering visitors and much-needed products to the large piers stretching into the bay attached to the hotels and inns. Some were 300 feet long. It was no surprise when a 1,120-foot pier was built advertising a large excursion boat would be coming from Philadelphia to Fortescue twice daily. But it only lasted a few months. Eventually, there were no more horses and buggies and large excursion boats, and trolley cars would carry visitors. They were state-of-the-art technology, linking small towns together: Bridgeton to Millville, Millville to Port Norris, and Port Norris to Newport, where entrepreneur George Duffield and Chester Bradford would meet the trolleys and taxi patrons into Fortescue by horse and buggy. Later Bradford upgraded the taxi to an old Packard he called *Rapid*. Soon the trolleys received competition from the Zellers bus company. Around 1930, the trolleys would cease to run, another era gone.

The first firehouse in Fortescue, located on Pennsylvania Avenue, was large enough for one engine. The first responder vehicle was a 1929 Rio. The firehouse was so small that when William Frient, the first fire chief, called a meeting, the truck came out so the firemen could get in. The second firehouse was on Delaware Avenue. The company was able to purchase two buildings and join them together with a breezeway. Movies were shown there by Joe Strain of Mantua, son of David Strain Sr., who showed movies at the old Fortescue pavilion in the 1930s and 1940s. In 1978, ground was broken on Cornell Avenue for a new, more efficient firehouse that could hold six to eight fire apparatus. The close-knit community of Fortescue graciously supported the fire company.

In this picture, taken in 1930, the small building at the top of the picture on Pennsylvania Avenue is the first firehouse in Fortescue. The firehouse had its own well and was also hooked to the main water line in town. Many hot summer residents had no well or were not tied to any water system, and they depended on the firehouse for their water. Often there were pickup trucks with large washtubs, frequently getting their supply of water for bathing or laundry from the small firehouse.

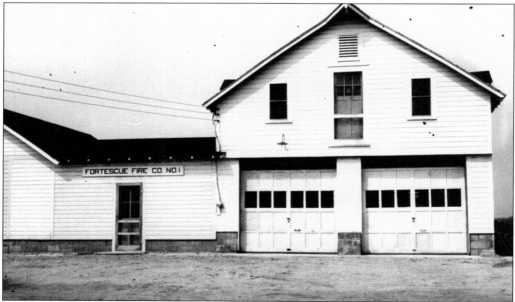

When the Fortescue Fire Company saw the need for a new larger firehouse, it purchased two homes on Delaware Avenue and joined them together with a breezeway. In the summer, movies would be shown by Joe Strain. Soon another, much larger firehouse would be built on Cornell Avenue, and this old firehouse became Ken's Apartments.

1978

A NEW FIREHOUSE IN FORTESCUE, N.J. FOR FIRE DISTRICT
NO. 1-DOWNE TOWNSHIP, CUMBERLAND COUNTY, N. J.
THIS PROJECT BEING FINANCED BY THE
FARMERS HOME ADMINISTRATION

FmHA

Architect..... PAUL LEE HECKENDORN, A.I.A.

Engineer... GEORGE A. SCHOCK ... ATES

Contractor... S CONS TI

1978

Seen here breaking ground for the third and newest Fortescue firehouse to be built on Cornell Avenue are five jubilant firemen, from left to right, Clifford Higbee, Ronald Loper, Frank Green, Norman Smith, and Fire Chief Clarence Higbee. This firehouse would replace the one on Delaware Avenue. The picture below is the finished firehouse with the siren and three very deep bays to hold the trucks and boats for land and water rescue.

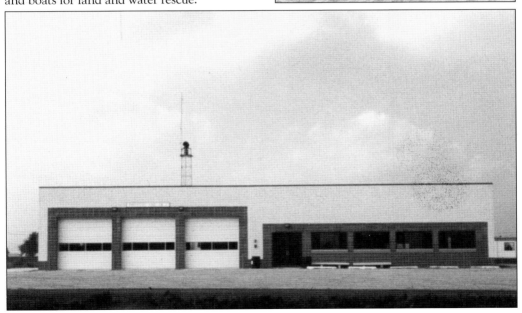

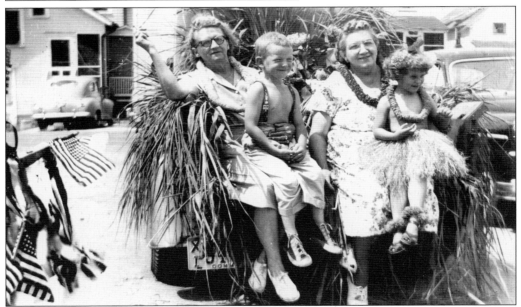

DEAR FORTESCUE RESIDENTS AND VISITORS

 MAJOR MOTION PICTURE COMING TO FORTESCUE, N. J.
WE WILL BE PRESENTING JAWS SOON, AND WOULD APPRECIATE
THE PLEASURE OF YOUR ATTENDANCE, ADULTS AND CHILDREN.
PLEASE HELP US SUPPORT OUR MOVIES FOR THE 1980 SUMMER
SEASON BY ATTENDING THIS MOVIE WITH US. THIS IS A NON
PROFIT SUMMER ACTIVITY IN FORTESCUE.

Saturday and Sunday Afternoon Shows

2 P. M. $1.25

Joe Strain Presents The Movie

JAWS

SATURDAY & SUNDAY
JULY 19-20 1980
8 P.M. SHARP

Donation $2.00

FORTESCUE FIRE COMPANY NO. 1

This *Jaws* advertisement was from 1980. *Jaws* was one of the most popular movies shown at the firehouse on Delaware Avenue.

In 1948, the first Fourth of July parade was held, sponsored by the Ladies Auxiliary of the Fortescue Fire Company. Mildred Higbee's old bait truck, decorated with marsh grass, brought many a smile as Clara Doms, holding Fred Walston, and Marilee Higbee on the lap of Florence Pestor passed by like a tropical breeze. The parade continues to be an earsplitting, flag-waving, bedecked–bike riding, candy-tossing, patriotic tradition that folks love.

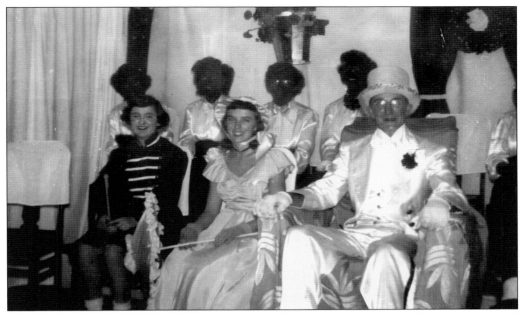

In 1950, the Ladies Auxiliary of the Fortescue Fire Company put on a minstrel show written and directed by Mildred Higbee. Over half the town participated, and the gala was sold out for two nights. Among the entertainers were baton soloist Jane Garrison, umbrella dancer Alice Ann McCabe, and interlocutor Frank Rodenbaugh.

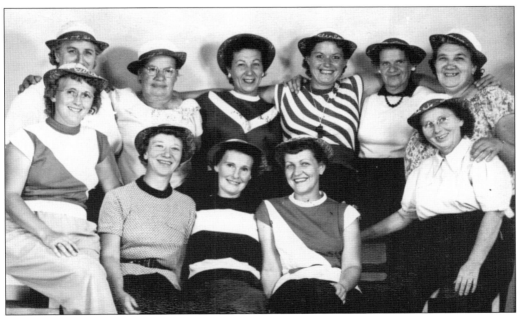

This postcard features the first Ladies Auxiliary of the Fortescue Fire Company in association hats. Pictured from left to right are (first row) Mary Jane Hartley, Mary Hurley, Mrs. French, Betty Pharo, and Mary Cole; (second row) Jeanette Cossaboon, Ann Senecal, Yvonne Walston, Mildred Higbee, unidentified, and Florence Pester.

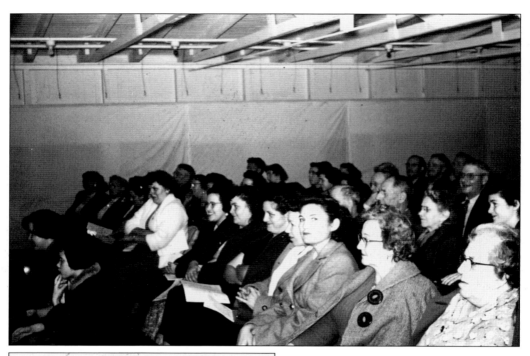

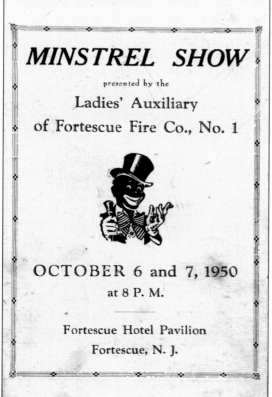

MINSTREL SHOW

presented by the

Ladies' Auxiliary
of Fortescue Fire Co., No. 1

OCTOBER 6 and 7, 1950
at 8 P. M.

Fortescue Hotel Pavilion
Fortescue, N. J.

Above, the audience watches the minstrel show presented by the Ladies Auxiliary in 1950. At left is the playbill for the show. The event was held at the Fortescue Hotel Pavilion.

In 1925, the very informal interdenominational chapel was built by the H. H. Hankins lumberyard in Bridgeton after Elizabeth Garrison went from cottage to cottage petitioning for pledges. The first minister was Leonard Anderson. The pulpit, donated by Capt. Dallas Gandy, came from the old stone church in Fairton. David and Helen Blew donated the bell, and Henry and Irma Roever donated the organ. Ministers included Leonard Anderson, William Loder, William Van Fliet, Francis Champion, Leslie Dillon, Kurt Terhune, and Fred Goos.

Entering through the little chapel doors are Sophie Loper and Lillian Hamilton, two of the original charter members. Other charter members include Ida Green, Elizabeth Locke, and Francis Nickoles, just to name a few. The chapel was named the Lighthouse on the Bay.

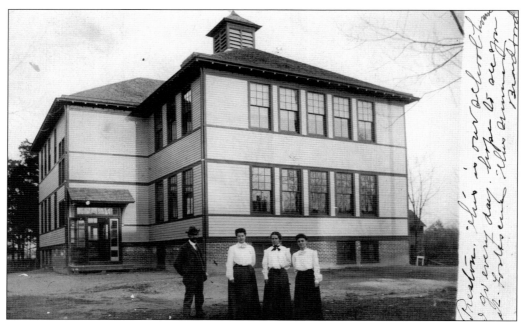

In 1902, the Newport High School on Fortescue Road was a three-year school. Students would finish their senior year at Bridgeton High School. In later years, the school accommodated kindergarten through eighth grade. The school was demolished in 1971.

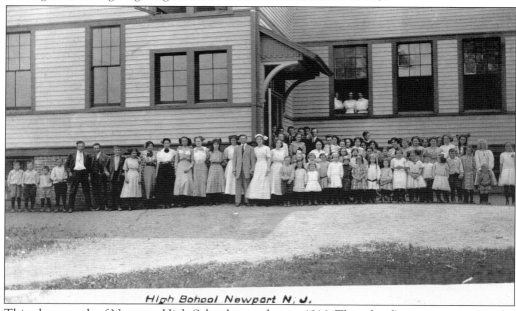

High School Newport N. J.

This photograph of Newport High School was taken in 1916. The school's song was sung to the tune of "Auld Lang Syne:" "We'll ne'er regret the days we spent, we'll ever give a sigh, for dear old days, for good days, our days at Newport High. Oh! Newport High, the grand old school, we'll give three cheers for you. Hurrah! Hurrah! For Newport High, and for the gold and blue. We'll dream again of lessons hard, and of classmates all. We're freshies first, then sophies next, then juniors last of all."

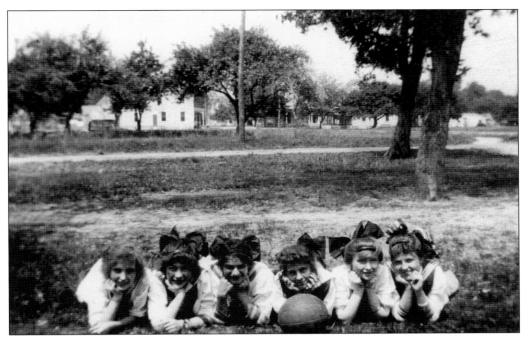

Members of the 1915 Newport High School girls' basketball team are, from left to right, Margaret Husted, Clara Bateman, Lillian Ross, Mildred Campbell, Rebecca Lore, and captain Mary Campbell. The girls believed in the spirit of hard work and fair play.

The Newport High School class of 1916 officers and cabinet pose for their yearbook. Pictured from left to right are (first row) cabinet members Hattie Page and Mary Cosier; (second row) president Anna Pashly, secretary Thelma Garretson, and treasurer Mary Lore.

The 1925 junior class of Newport High School included Elva Gerald, Irving Turner, Mary Etta Hackett, Servilla Howard, Rose Matias, and Hazel Moore.

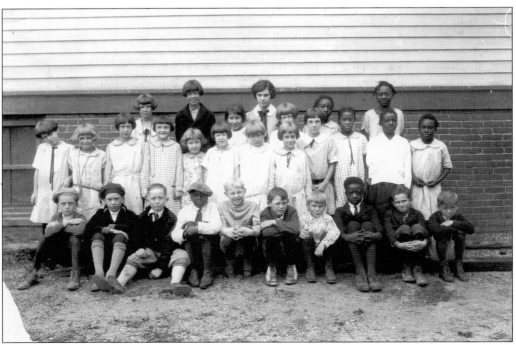

Ethel Ryan is posing with her students in front of the old Newport School.

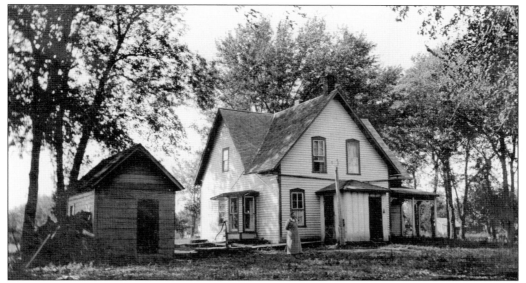

This is Turkey Point school, built around 1883. All children in the Dividing Creek and Turkey Point area attended school here. Church services were also held at times in the small school on Hickman Avenue.

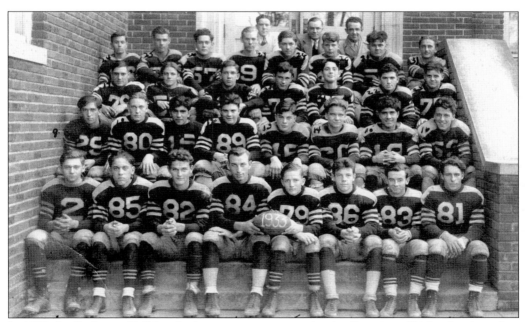

In 1933, the Bridgeton Bulldogs had a winning season under the direction of high school coaches Robert Riley, Richard Guest, and William Maloney. Many of these football players were students from the Newport School District. In the front row, at center, is Miles Gandy (No. 84). He later became the owner of Gandy's Beach and Marina and was responsible for the island's growth and development.

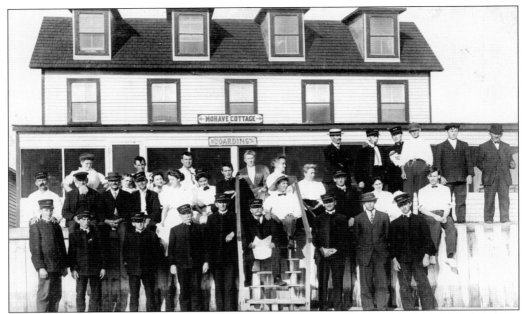

In 1915, there was a trolley conductors meeting. The men are dressed in working apparel. A large group of conductors poses with friends and family in front of the Muhave Cottage located on the southern end of Fortescue on the beachfront. The conductors drove the trolleys from Millville to Port Norris. When the trolley arrived at the depot in Newport, Chester Bradford would be there to transport the passengers in his horse and buggy or old truck into Fortescue.

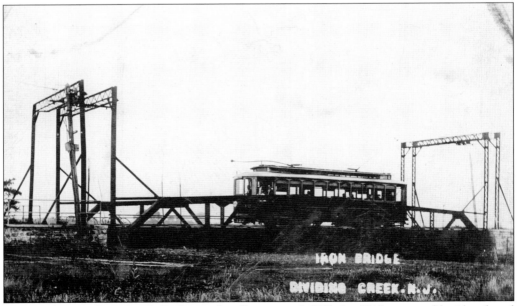

This is the Dividing Creek Bridge and trolley around 1765. In 1805, it was dilapidated and was rebuilt as a drawbridge. However, the bridge required constant repairs, so in 1825, another drawbridge was built, but it required constant repair also. Soon the drawbridge was replaced by a truss bridge and is still in good working order today.

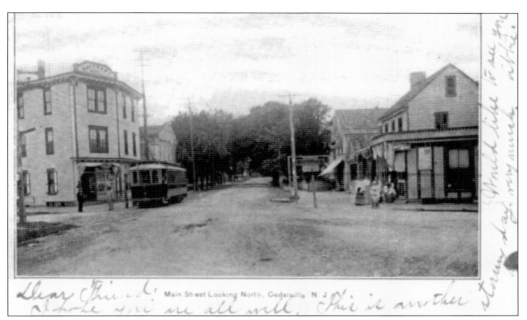

Main Street Looking North, Cedarville, N. J.

An ordinance for permission for running a trolley line through Cedarville was introduced in 1894. The trolley is stopped in front of the Bateman Building. This building once housed a pool hall and a Catholic church on the upper floors. Many people remember Pete's Restaurant, which is now Dino's, on the first floor.

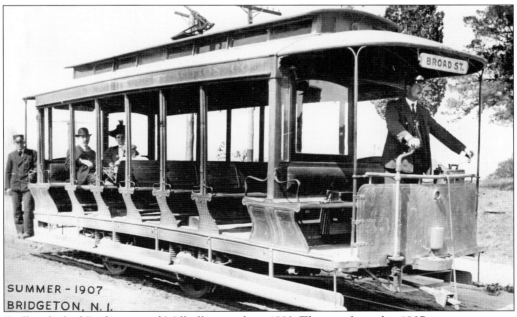

SUMMER - 1907
BRIDGETON, N. J.

Trolleys linked Bridgeton and Millville as early as 1893. The couple in this 1907 picture seems to be enjoying a summer ride on the old Broad Street trolley in Bridgeton.

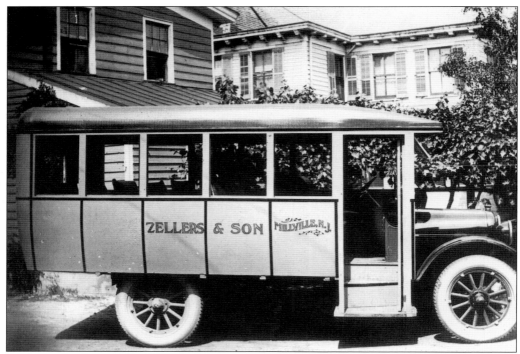

Early in the 1920s, Zellers and Son transportation buses gave the local trolley cars a little bit of competition on the Millville–Port Norris route. Shopping became a little easier for the Newport and Dividing Creek residents.

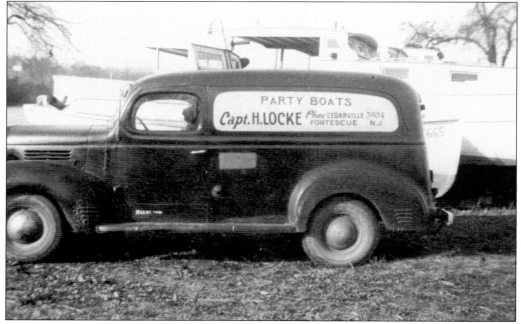

Horace Locke, captain of the boat *Lucky Lindy*, and his wife Betty drove this traveling billboard, a sedan delivery truck, from Fortescue to Florida every year.

Nine

PEOPLE AND THE THINGS THAT MATTER

For being such a small town, Fortescue has always been a happening place. The nearly 500 year-round residents are diverse, but the camaraderie is amazing. Every day has a tale to tell, like when the bay froze over in 1915 and thousands came to skate on the 10-inch-thick ice. Otis Husted from Bridgeton drove his motorcycle, and Jacob Mulford took his Model T Ford over three quarters of a mile on the frozen bay. Someone even drove to a lighthouse to bring in a keeper. How humorous it must have been when on the same beach after the thaw, women were seen pushing baby coaches looking for bottles of alcohol after they heard a load had to be thrown over the night before, hoping to find a bottle or two. Residents who worked the water for a living loved the small grocery store of Charles Nickoles. His motto was "buy anything you need and pay on pay day." With Betty Locke working behind the counter, one also received the beloved green stamps. Today Linda (Depriest) Robinson owns and runs the Dock Side Deli on Creek Road. She has been serving the public for 30 years with her wide selection of sandwiches and numerous flavors of ice cream while her husband John fills the shelves that line the room with much-needed essentials.

Some can remember when the first and second televisions arrived in town to the same address. They were delivered to Robert (Bob) Wilson, captain of the fishing boat *Bob Buck*. After local boys Ronald, Frank, Harry, Wayne, and Clarence helped Bob scrub the fishing boat, they were allowed to watch one of the two televisions, which were stacked one on top of each other. The boys watched *Frontier Playhouse* and *Howdy Doody* on the bottom television while Bob watched the news on the top television at the same time.

Some of the captains needed some fun and relaxation and joined the island's traveling baseball team called the Fortescue Croakers. They practiced on a field behind the Fortescue Chapel.

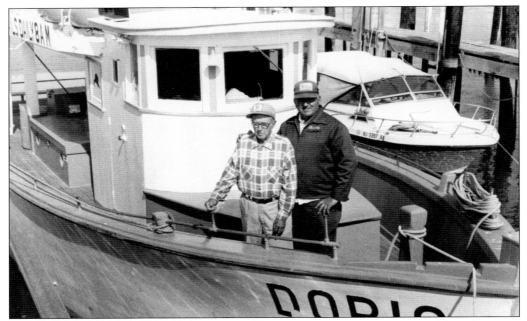

In this photograph, Capt. Andrew Gerard, 85, says it is time to give up the ship as he turns the keys over to the new owner, Clarence "Bunky" Higbee. The fishing boat *Doric* has sailed from the number one dock in Fortescue Creek for many years. *Doric* soon became the first *Miss Fortescue* fishing boat.

Henry "Hank" Maffei, junior captain of the charter boat *Duchess*, was second in line to three generations of boat captains. As a highly respected waterman, Maffei was singly elected president of the Fortescue Captains Association. With wife Beverly as his true first mate, Captain Hank proudly sailed the Delaware Bay for 30 years.

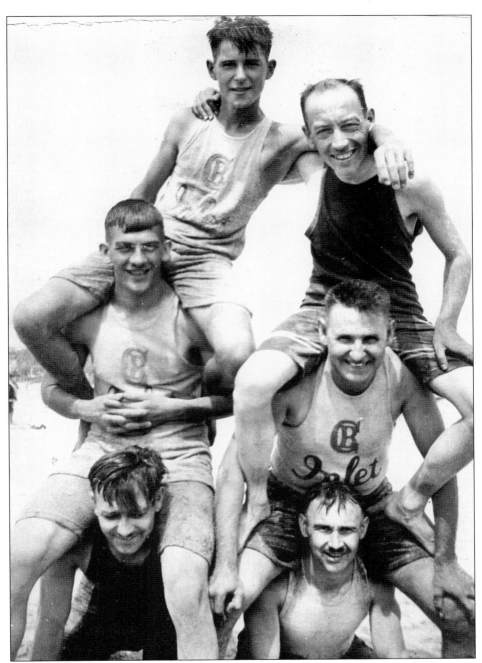

This picture was snapped in the 1920s. This bunch of Bridgetonians seems to be having some fun in the sun as they form a human pyramid on the sandy beach. Starting at the top of the pyramid, from left to right are Francis Pugh and Charles Ingersol; in the middle are Oscar Joyce and Thomas H. Pugh; and on the bottom are Joe Cambell and an unidentified man. Francis eventually owned a pier with boat rentals, and Thomas was responsible for the construction of many buildings in Fortescue, one being the Hotel Charlesworth. Ingersol had a barbershop on Washington Street in Bridgeton. (Courtesy of Caesar and Marlene's.)

John Loper, born in 1892, worked for the Garrison empire, first making ice every day and later operating their waterworks. He received his real estate license in 1924 and was responsible for selling every lot in Fortescue. He was also the first member of the township committee, became a constable, and was the first harbormaster. In 1930, he built and operated Loper's Municipal Hotel, had a gas truck for fueling party boats, and ran the only legal bar in 1933. He also owned and operated a bait and tackle shop.

Edward "tongue-tied Eddie" Storm was a handyman to everyone in town, especially captains who needed him to paint in the spring. This respected former prisoner of war could be seen riding a lawn mower, trailing behind several old wagons with mismatched wheels and abandoned baby coaches where the tools were kept. At times he drove this wagon train 18 miles to the nearest town. (Courtesy of George Davis.)

Lillian Hamilton, dubbed the "cookie lady" by children, operated a small store for over four decades on Garrison Avenue. She was known for making the best banana splits in the world. In her later years, selling the newspapers was her greatest challenge. This remarkable woman worked seven days a week from 5:00 a.m. until 6:00 p.m. until just shy of being 100 years old.

Mary (Garrison) Johnson, a close descendant of the Garrison empire, owned and operated a small family restaurant, the Garrison House, located on Fortescue Road in the trailer park campgrounds. Johnson has been featured in many newspaper articles and magazines, praising her for her famous crab cakes.

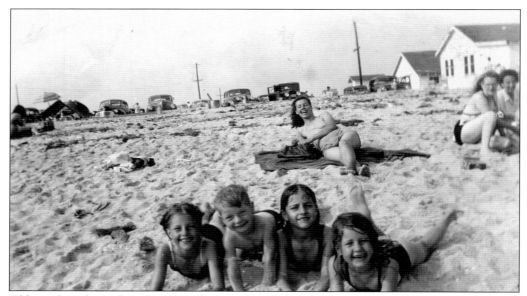

Old cars line the parking lot as the large and sandy beach was a great attraction for large family gatherings. Mae Rauschart and siblings Iva, Allen, Betty, and Helen enjoy a summer afternoon on Gandy's Beach. The two people to the right are sisters Connie and Mary Foster.

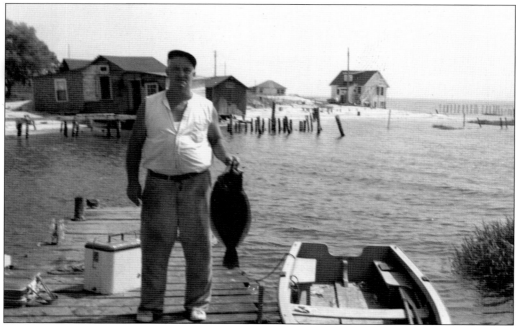

Here is the point of Raybins Beach in 1940. On the right side of the bridge, small cottages were everywhere. Leonard Sanders holds a prized flounder on his dock.

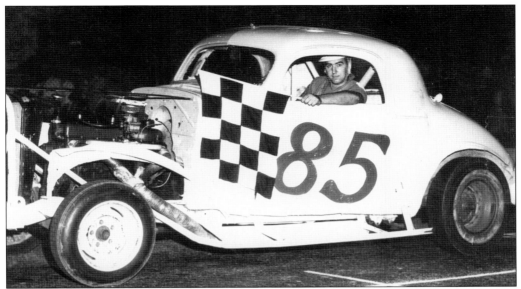

In 1957, Higbee brothers Clarence, known as "Bunky," and Harry decided they wanted to do something more exciting than hunting and fishing and joined NASCAR to go racing. Their cars were the opposite: Bunky's was blue and white, No. 85, and Harry's was white and blue, No. 58. The boys honed their skills on the old Fortescue raceway, which was a road course, specifically the road between Newport and Fortescue. After a few years of racing, Harry decided to call it quits, but not before winning many feature races. Bunky went on to race many more years with his number one pit crew person Sam Blizzard at his side for every race. Not having their own garage at that time, they rented Joe Jacquett's on Baptist Road in Newport. Bunky became a legend in his time. In 2001, he was inducted into the All Sports Museum of Southern New Jersey Hall of Fame.

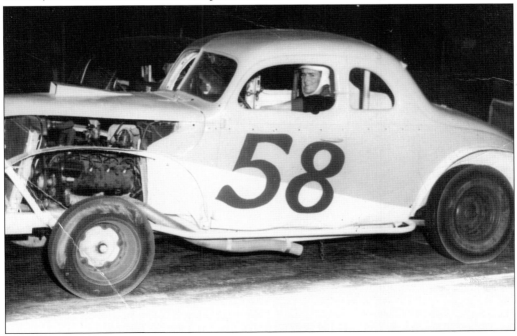

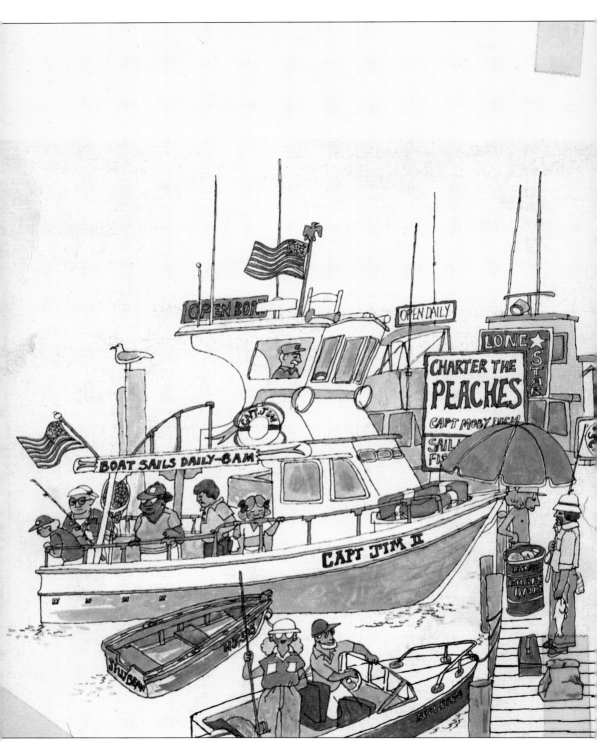

Fortescue caught the eye of children's book author Barbara Bruno. This is a delightful and lighthearted cartoon version of the Fortescue Marina and the fishing fleet by the author. This is

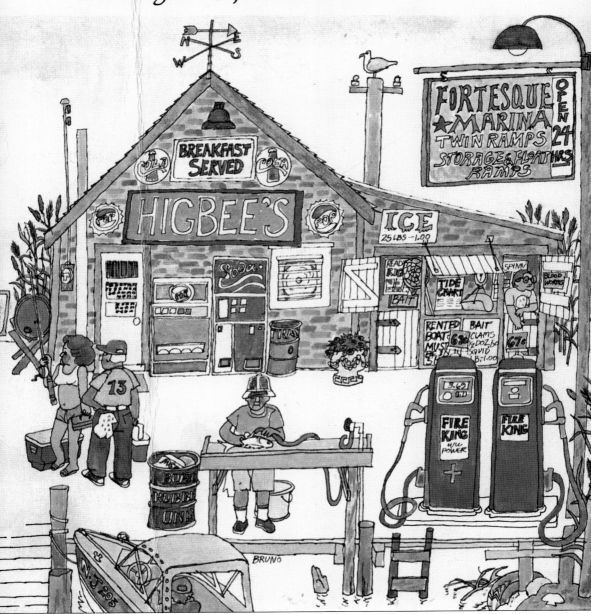

the volume 7, No. 11, July 1980 issue.

The speakeasy known as the Green Door was located on Pennsylvania Avenue. The entrance was positioned under the stairs with a peephole in the door. A jukebox for dancing and a dart game awaited the adventurous patron.

Mildred Higbee was the owner of the largest speakeasy in town, the Green Door. The Green Door was always decorated in a nautical theme. Crabs and shrimp were served every Friday and Saturday night along with the illegal alcohol.

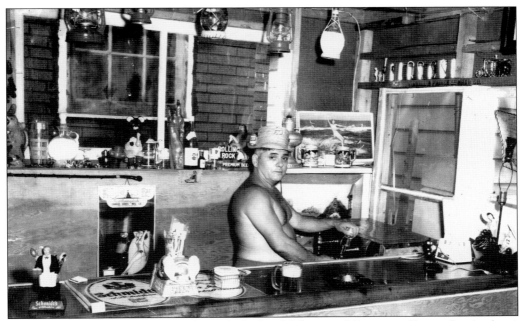

Squeaky's speakeasy was very popular with the local folk around Fortescue. Pictured is Anthony "Squeaky" Asselta wearing his familiar trademark hat and placing a mug of beer on the counter. Although Squeaky and his wife Marge have both passed away, the speakeasy building is still in the same location on New Jersey Avenue.

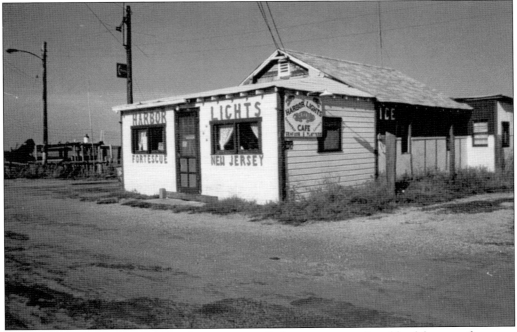

Harbor Lights Café on Creek Road was a quaint little restaurant enjoyed by fishermen for many years. Back in the 1940s, the restaurant served as a speakeasy for Martha Williams, who had a partner who was a boxer named Kid Lightning.

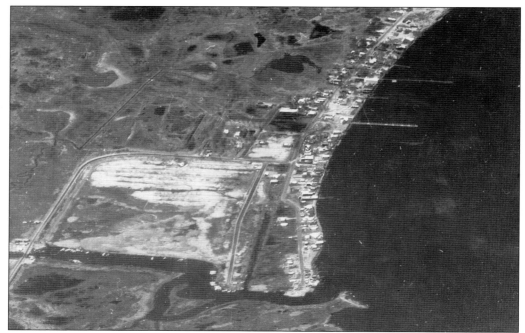

In 1930, Fortescue Creek was dredged to get rid of a small island running parallel to the creek bank. Herbert Garrison allowed the spoils to be placed between Dobune and Garrison Avenues banked to hold in the sludge. After seven years, building lots were designed and sold for approximately $100 each.

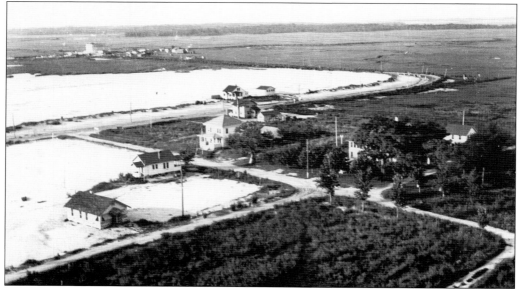

In 1930, a scattering of new homes started to line the landscape as captains decided to stay permanently and make their living on the Delaware Bay. Captains Charles Gandy, Charles Garrison, Joe Reinhardt, Clarence Higbee, and Charles Bowen owned these homes on Pennsylvania Avenue. Also notice the Garrison Lodge in the upper left hand-side of the picture.

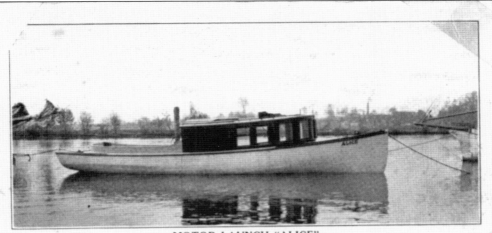

MOTOR LAUNCH "ALICE"

CAN BE HIRED FOR PLEASURE AND FISHING PARTIES

ACCOMMODATIONS FOR LADIES

BELL PHONE 29-R21
HUNDERMARK HOTEL

CAPT. JESSE DARE, FORTESCUE, N. J.

Rumrunning was as much of an activity as fishing and hunting were, but it was much more lucrative. Bootlegged alcohol was a great challenge for the captains, who would go and meet the ships carrying whisky, which some came as far away as Jamaica and Canada. There was a five-mile limit that was safe from federal agents. Some captains used their fishing boats as "by boats" that took from the big boats and brought the rum to shore to the waiting trucks on the beach. On some nights, large amounts of people would come to Fortescue and just sit on the beach or walk the boardwalk to see the illegal activity going on by watching the lights and their eerie signals. It was a dangerous game, but the profits were high.

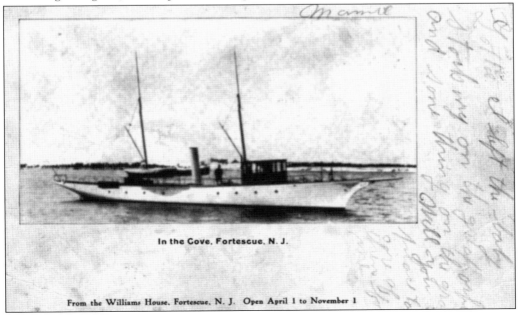

In the Cove, Fortescue, N. J.

From the Williams House, Fortescue, N. J. Open April 1 to November 1

AN EXHIBITION
OF WATER COLORS
AND OIL PAINTINGS

FORTESQUE
PAINTING SHOW
Philadelphia Sketch Club
Galleries
235 SOUTH CAMAC STREET

AT THE
PHILADELPHIA
SKETCH CLUB
JUNE 5 TO 16, 1950

The Philadelphia Sketch Club was established in 1860. The artists found retreats for their sketch club outings. During the war, members accepted the invitation of Hubert Foster to come to Fortescue. They were so pleased with the hospitality and the ever-changing scenery that they soon came to Fortescue in larger groups. Hubert Foster lived in the Saltbox on New Jersey Avenue, and his brother Preston's Seahorse Cottage was next door. The visually pleasing artwork provides and preserves the historic appearance of the community and its daily activities. Many of the paintings were sold locally, while some were given to hospitable neighbors. Part of the charm of the sketch club included its theatrics and pranks. Of course the flow of alcohol contributed to its escapades, but it also produced beautiful works of art. Fortescue paintings are highly sought after today.

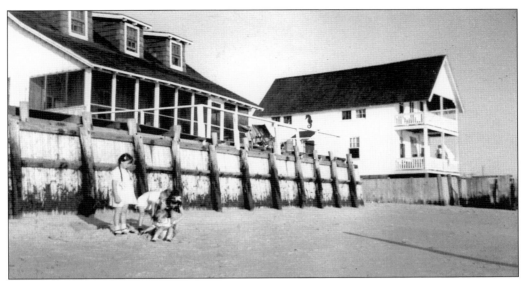

The Saltbox belonged to Ida and Hubert Foster, and the Seahorse Cottage was the summer home of Fannie Bateman Foster, her son Preston, and his wife Amy Hand Foster. The cottages were first utilized by the Philadelphia Sketch Club for its annual outing in the early 1940s. The club sketched, painted, and photographed Fortescue homes and happenings for a span of over 20 years. The Seahorse Cottage remains in the Foster family and is presently owned by Fannie's great-granddaughter Pamela Foster Brunner and husband Robert. The children playing on the beach in this late-1940s photograph are Fannie's grandchildren.

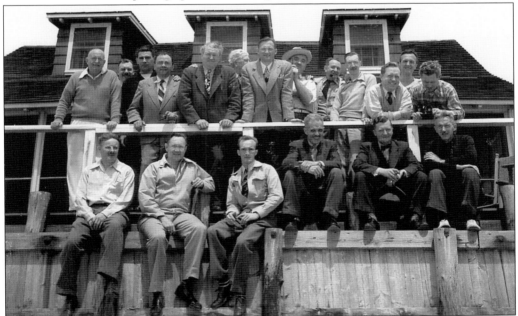

Members of the Philadelphia Sketch Club pose in front of Hubert Foster's Saltbox during a Fortescue outing in the 1940s. Sketch club members enjoyed the island retreat for over 20 years. Past club members of note include Peter Boyle, Thomas Eakins, John Geiszel, Hugh M. Hutton, Norman Guthrie Rudolph, and N. C. Wyeth.

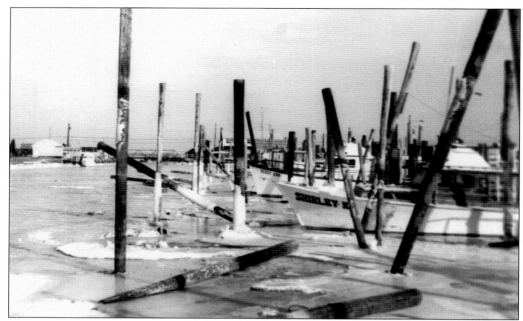

Major damage and devastation in the creek caused by the extremely cold winter played havoc on the pilings and piers. In 1977, the cold weather caused Fortescue Creek to freeze for days. The pilings pulled out were broken, and the piers were twisted and destroyed, resulting in the captains association seeking state aid to repair the marina for the upcoming season.

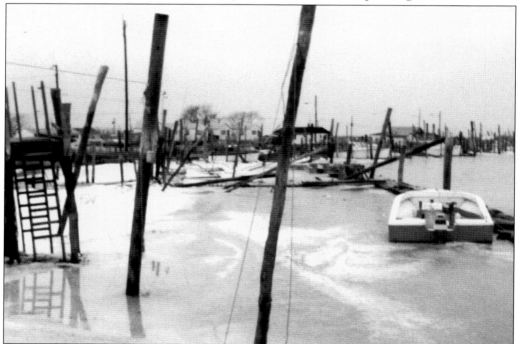

The owner of this boat said, "Should have taken my boat out sooner." Piers, docks—they were all destroyed. There was nothing that could be done until the weather warmed and there was a thaw.

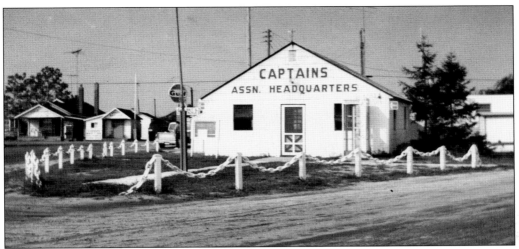

The state marina was organized in 1951, with headquarters built on Creek Road and Garrison Avenue, to oversee the fishing fleet. John Loper was the first harbormaster. The original lease signers were Joseph Reinhardt, Joseph Pugelise, Nelson Corson, Isaac Boone, Benjamin Quadling, and Horace Locke.

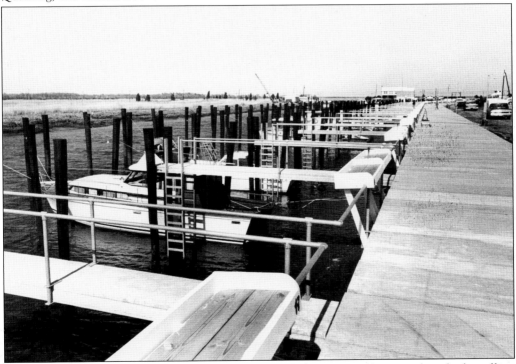

In 1976 and 1977, weeks of extra-cold weather caused the water to freeze inches thick, pulling every piling and twisting every pier. Specialist Milton Pepper of Pepper Construction was called in for advice. Soon he was driving pilings 30 feet down and pouring new concrete piers. After three arduous months, renovations were done. A ribbon-cutting by dignitaries Congressman William Hughes, Gov. Brendon Byrne, and state legislators Charles Caferio, Joe Chinnice, and Jim Hurley made the captains proud.

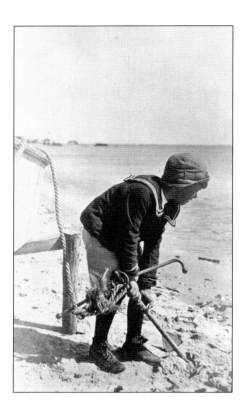

A stylish, young Foster lad readies the anchor on Fortescue Beach near the Williams House. The far south end of the island can be seen in the background.

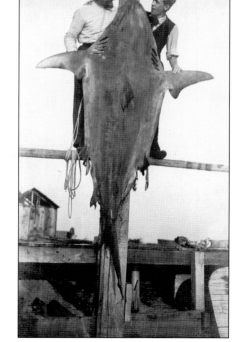

Naturalist Mulford Foster of Elmer (right) found an awesome way to display this very large shark. The other man is unidentified but appears to be a Fortescue fisherman.

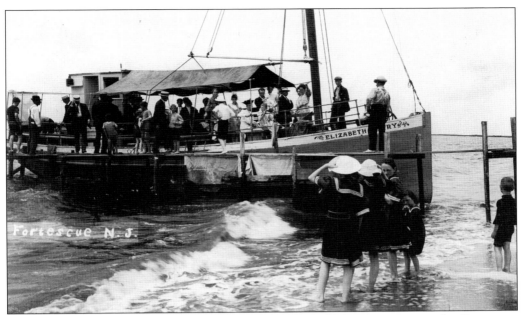

In 1909, Herbert Garrison's grand excursion boat the *Elizabeth Mary* was quite popular. Passengers boarded the vessel at Garrison's Pier, delighting the young onlookers in their "all the rage" sailor dress. In addition to passengers, the boat carried freight up and down the Cohansey River.

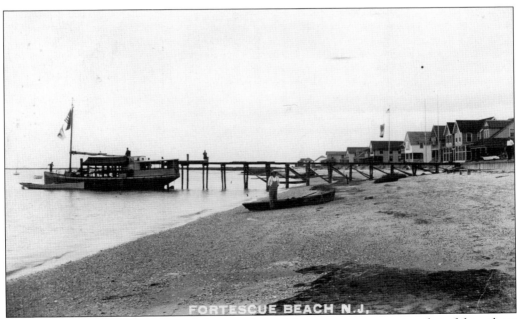

It is an early morning in 1910, and the captain and first mate are preparing their fishing boat while waiting for the customers to arrive for a day of fishing. The small boats could also be rented by one or two people, who would have to row out as there were no motors on the boats.

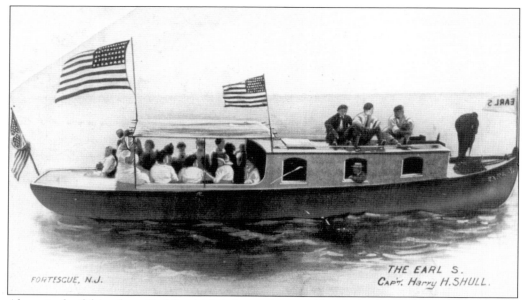

Above is the fishing boat *Earl S*, which is being skippered by Capt. Harry Shull. Shull lived on a houseboat in the 1800s where Higbee's Marina is now located. He was found on the boat, shot to death by his own army rifle. Robbery was suspected, as the daily payroll was missing.

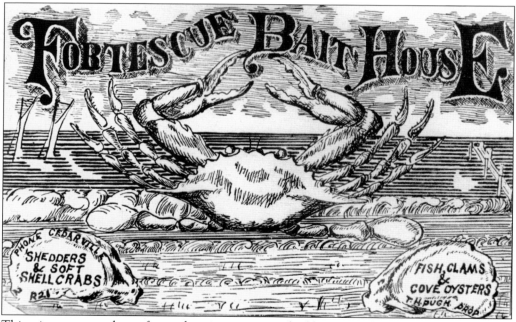

This picture was taken of an advertisement on a building owned by Thomas Pugh. This photograph was made into a postcard and became one of the largest-selling cards of its kind.

On a hot, busy summer weekend in 1947, Sander's Marina and Horns Marina had to close when George Slade's dump truck fell through the bridge at Raybins Beach, creating quite a dilemma.

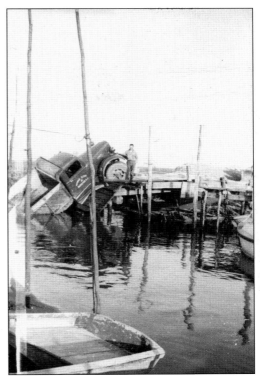

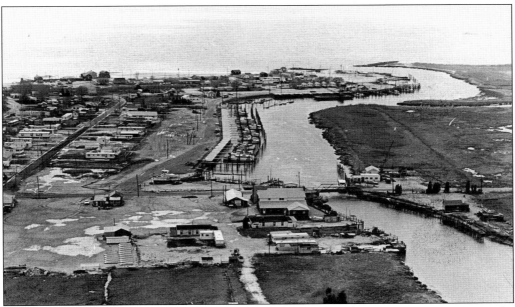

Alvin and Frances Luca's restaurant Peaches was located on Garrison Avenue. Next to the restaurant, Alvin placed five small motels he purchased from Highway 77 Motels in Bridgeton. Eventually the first two motels were joined together to make Al's Bait and Tackle shop. The next two were joined together to make Al's new home. The fifth is still standing today in its original state. They are located in the picture at the top right near the big bend in the creek.

Fortescue folks created an early version of the boogie board by rounding off the top of a heavy door and attaching a rope. A rug was glued or tacked to the bottom half of the door to protect the knees. Owners personalized their boards with paint. During the summer, these oversized water toys, dubbed the "skimmer," could be seen skimming up and down the creek behind a motorboat.

During the 1800s, captains would follow the run of fish from Cape May to Philadelphia, living on houseboats along the way. These floating homes usually measured 12 feet by 16 feet with a small porch on each end. A shad skiff was used for towing. When the captain spotted fish, the houseboat was pulled on the bank. Come winter, the houseboat was towed to the mainland and the captains went to winter jobs, usually in the glasshouses. Due to excessive heat during July and August, the glasshouses closed for those two months, giving the captains free reign to fish. (Courtesy of Betty Gifford.)

The sign says priced for quick sale, but the sale was not quick enough. The Delaware Bay swallowed this cottage right up, only one month after the sign was placed on it.

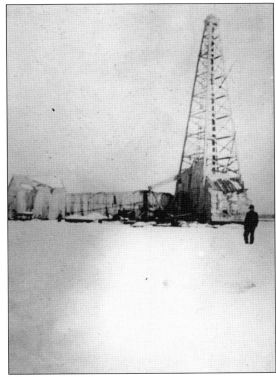

In 1918, the property of Milton Lupton above Beaver Dam was leased by an oil company. It erected a tower, and a well was driven with hopes of striking oil. None was ever found, but it made for interesting conversation and excitement.

HOTEL FORTESCUE

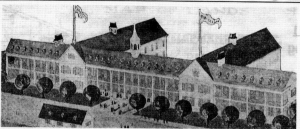

SPECIAL DESIGNED HOTEL PLAN FOR FORTESCUE

A Modern Two Hundred Room Hotel

The above etching is a proposed plan for a modern two-hundred room hotel at Fortescue, being the first and last word in beauty, art and public comfort. The above likeness has been reproduced from the original drawing, especially designed as the future "Hotel Fortescue," and is herein shown as it will actually appear after complete construction.

Plans have already been determined for the proper drainage of this property, prevention of overflow waters, the necessary elevations to be created, where so needed, and that there will be not a single foot of this property unsuitable to the purposes for which it was intended. Each street throughout the entire tract shall be no less than fifty feet wide. Bids have been accepted for the making of streets, laying of cement sidewalks, planting of trees, shrubbery, etc., for the general beautification of a "Better Fortescue."

Also, be it said, the proposed plan of an 1800-foot pier, which is to be placed directly in front of the hotel, for the landing of large boats, will add thousands of visitors, besides offering excellent pier fishing to those who are unable to indulge in deep-sea fishing on account of seasickness. Ordinarily, the very best of fishing is to be had but a few hundred feet from the banks of the bay.

Cost of your Summer Vacation at the Seashore

Would soon pay for a bungalow site at Fortescue, NJ. A regular visitor to Wildwood made the remark that he had spent enough money in the past three seasons providing accommodations for his family at the seashore to pay for a bungalow site and a bungalow, and his experience had convinced him that the solution of real summer pleasure, for health and comfort, is a place of your own, even though it be a small place, when it combines convenience with home comfort.

Doubtless, the same thought has been in the minds of hundreds who forsake city homes, offices, shop and factory during the heated term for health and recreation. Why not put the money you spend every year into a place of your own? It will then belong to you 365 days in the year. Enjoy the benefit of your investment. Let it work for you.

If you do not wish to occupy your bungalow the entire summer, rent it. There is always a demand for bungalows that can be rented at a moderate price. For instance — a bungalow costing you complete, with lot, $750.00, should rent readily for the season at $125.00; by the month at $40.00, or by the week at from $10.00 to $12.00.

Special Inducements to Clubs and Individuals who wish to Build Now

You do not have to pay for your lot in full before you are permitted to build your bungalow. You PAY ONE DOLLAR DOWN and you are given IMMEDIATE POSSESSION of the ground, upon which you can build at once, paying the balance at a rate of from FIFTY CENTS to SEVENTY-FIVE CENTS per week, excepting a few of the higher-priced lots. There are NO TAXES OR INTEREST to be paid by any purchaser for TWO YEARS. This method makes it easy for clubs, where a small weekly assessment of each member would never be missed. By this method they would soon own their own outfit and it is growing into money each year, affording very cheap, profitable pleasure to its members. If you are a man personally desiring such accommodation for your family, there is little reason why you should not do so. It goes without saying that this is the FIRST AND ONLY summer home property ever to be offered the public under such liberal terms of purchase.

Advantages of Purchasing Your Site Right Now

If interested in this property, there will be no advantage in delaying your purchase. At the opening sale these sites will naturally be sold at considerably reduced prices. Do you want to be in on the GROUND FLOOR of this property? Or would you rather wait from six to twelve months later and pay from TWO to FIVE times the PRESENT SELLING PRICES? This is just what you will do, providing you do not act quickly. There is no reason why you should not SECURE your PREFERRED LOCATION immediately. The ONE DOLLAR you pay down secures your lot and the FIFTY to SEVENTY-FIVE CENTS you are obliged to pay weekly upon each lot would cost you but little money, up until such time as you will be able to personally see the wonderful improvements actually being made at Fortescue. It is positively certain that there will never be a single foot of ground within this tract that will ever be sold for a dollar less than it is being offered RIGHT NOW.

Here is an advertisement for a proposed 200-room Hotel Fortescue that never materialized.

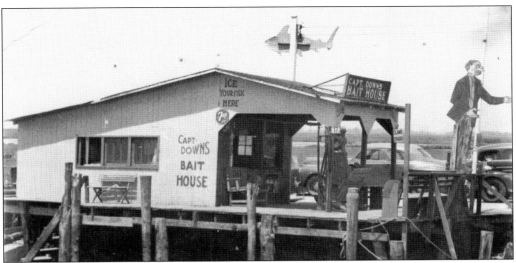

This picturesque bait and tackle shop was built in the 1930s by Aven Down by the bridge. Although it had a number of owners, the name always remained the same: Down's Bait Shop. Current owners are the Strain family. Ethel, her son Joe, and her husband Capt. David Strain Sr. are behind the luncheonette. The fishing boat *Kingfisher*, built by David and his son David Jr., ran from the store on a daily basis. After the death of Captain Strain, David Jr. took over the business and built another boat at his home in Mantua along the Mantua Creek, the *Kingfisher II*. A rail that went from the backyard right into the creek was used to launch the *Kingfisher II* and get it to Fortescue. Mother Ethel still manned the grill with waitress Myrtle Robinson. David Strain was the man behind the projector that showed all the movies at the popular Fortescue Pavilion.

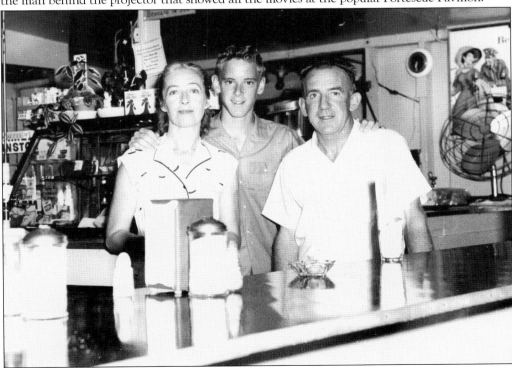

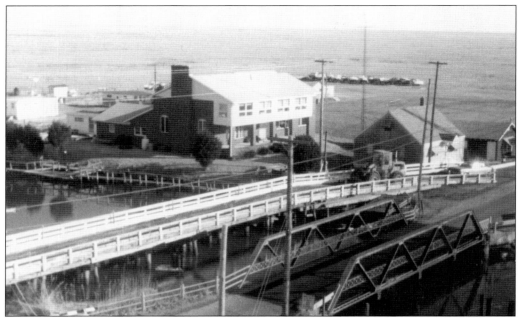

This aerial view shows just how close the temporary bridge came to the home of Clifford and Bertha Finley. They were unable to use the front entrance of their home. Bertha had been putting up with so much dust and noise for so long she decided to move her house to Princeton Avenue, now the home of Clifford Higbee.

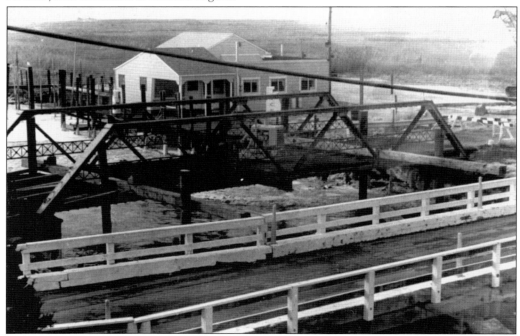

The old one-lane iron bridge was used from 1904 to 1981. When the temporary bridge was completed, it was time to dismantle one of the wonders of Fortescue and start a new modern era with the coming of the new bridge.

To ALL MY FRIENDS AT HIGBEE'S
MARINA IN MY HOMETOWN OF
FORTESCUE, N.J.
THANKS FOR ALL YOU DO IN
SUPPORT OF THE COAST GUARD!
MCPOCG C. Bowen

Master chief petty officer of the Coast Guard Charles "Skipper" Bowen was born in Fortescue in 1959 to Charles and Joyce Bowen. He is the grandson of former Fortescue postmaster Gladys Mae Sharp. On June 14, 2006, Master Chief Bowen became the 10th master chief petty officer of the U.S. Coast Guard, the highest rank an enlisted man can receive. He lives with his wife Janet and four children, Mason, Joshua, Joseph, and Kristen. Mason is currently following in his father's footsteps on active duty in the U.S. Coast Guard. The Coast Guard plays a huge role in the U.S. Department of Homeland Security.

ACROSS AMERICA, PEOPLE ARE DISCOVERING SOMETHING WONDERFUL. *THEIR HERITAGE.*

Arcadia Publishing is the leading local history publisher in the United States. With more than 3,000 titles in print and hundreds of new titles released every year, Arcadia has extensive specialized experience chronicling the history of communities and celebrating America's hidden stories, bringing to life the people, places, and events from the past. To discover the history of other communities across the nation, please visit:

www.arcadiapublishing.com

Customized search tools allow you to find regional history books about the town where you grew up, the cities where your friends and family live, the town where your parents met, or even that retirement spot you've been dreaming about.